Concrete 2 Canvas:
More Skateboarders' Art

Jo Waterhouse

Laurence King Publishing

LAURENCE KING

Published in 2007 by Laurence King Publishing Ltd
361-373 City Road
London EC1V 1LR
United Kingdom

t: 020 7841 6900
f: 020 7841 6910
e-mail: enquiries@laurenceking.co.uk
www.laurenceking.co.uk

A catalogue record for this book is available from the British Library

ISBN – 13: 978 1 85669 531 2
ISBN – 10: 1 85669 531 X

Designed by Stef Grindley - www.selfctrl.net
Printed in Singapore

Cover
Thomas Campbell, **Scrapamortis #47”**, acrylic, spray paint, pencil, gouache, india ink on paper and sewn together.
Photo: Jeff@MG Imaging

Contents

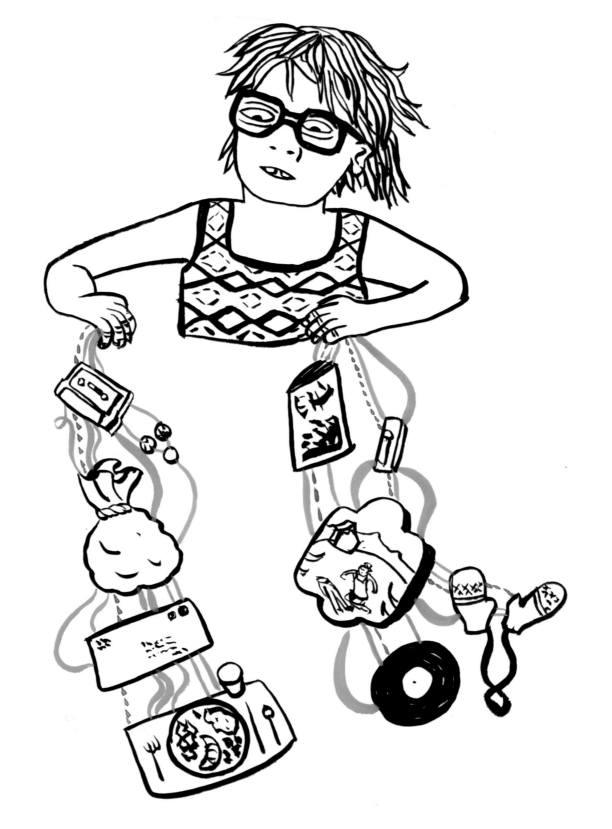

Foreword

Words & Picture by Lori Damiano

When I was a miniature lady, with about eight years to my name, I became enlightened. I have always favoured eavesdropping, and it was because of this pastime that I found the inspiration that has since guided almost my every move. I overheard a woman talking about her daughter having this 'skateboarder friend'. The woman was very impressed with this young man. She said he was always making things – little homemade magazines ('zines'), mix tapes and artwork – and giving them to his friends as gifts. Then it came; what was to become my mantra, my anthem, my own personal fight song. The woman said, 'Those skateboarders are so creative and generous!' These luminous words raised up gloriously against the sky, shape-shifted into delicate little arrows of intention and shot into the most sacred chamber of my brain where they would lie dormant, incubating and immaculately preserved for years. I decided then and there that it was my destiny to become one of these 'skateboarders'.

It sounds impossible, I know, but I could not figure out how I could actually become a skateboarder. Maybe, if you are a female human being, and you've ever had the experience of suddenly seeing another female human being doing something that you had never before seen a female human being do, you might understand what I mean. But otherwise I know it must be unfathomable that it never occurred to me just to step on to a skateboard. I spent many an afternoon sitting against the wall of the doughnut shop watching my friends skate our beloved local red-painted kerb. I had never seen a girl ride a skateboard in my life, so somehow, I guess subconsciously, I had concluded that there must be something about the structure of the female form that made skateboarding physically impossible. It wasn't until one of my friends rolled his board across the parking lot to where I was watching and asked, 'Why don't you try it?', that I even considered the possibility. I did try it that day and I have continued to try it over and over again as much as I could in the years that have passed since. That skateboard has rolled me right into the greatest adventures I've ever found, all over this good green earth, and right into the lives of all of my most beloved friends.

You meet a lot of people and see a lot of places skateboarding. And when you make things (zines, mix tapes, artwork), your hands can be busy as they come into contact with the new people and places you find. It is a blessed thing to be able to come bearing gifts, or to be the recipient of something that somebody made for you. That is the finest lesson skateboarding has taught me. The creative energy in skateboarding is stoked and constantly regenerating itself through these exchanges. The skateboarding community's common practice of trading objects of one's own fashioning has been responsible for allowing me to become friends with people – makers and sharers, heroes – whom I never would otherwise have had the chance to meet. I have always thought of the people throughout history who have offered something of themselves to the world and wondered what it would be like to have had the chance to know them had I lived during their lifetime. I started becoming aware of how many people in my own lifetime were inspiring me and motivating my own actions and decisions in my daily life. I realized that I had a chance to try and repay these inspirers with some of my own energy by making offerings of my handmade things to them.

Because it is quite rare to receive a personalized handmade gift in such a busy world, which thrives upon and celebrates mass-produced identical objects, my offerings have been very warmly received by friends and strangers alike. I am grateful to have found my way into this community of skateboarders who rejoice in making things, trading things and developing resources together to help reward and support one another. By creating something from your own heart and experience, and most importantly by offering it to the people of your time and times to come, a person has the chance to ensure that their existence and experience be reflected in the culture and society in which they live. This is especially helpful when the lifestyle in question is commonly misconstrued and misrepresented. I would like to thank skateboarding for all the lessons it has taught me, especially the one I have been describing here, but also for teaching me to climb fences, metaphorically sure, but mostly literally.

www.lori-d.com

Introduction

Words & Picture by Jo Waterhouse

The first *Concrete to Canvas* book was just the tip of the iceberg of artistic talent from the skateboarding community. *Concrete 2 Canvas: More Skateboarders' Art* brings you a brand new selection of artwork by skateboarders.

As with the first book, the art here is a varied mix of multimedia and multi-genre work. There is no one style, common thread or defining feature of the artwork: the only connection is that all artists are skateboarders.

The artwork itself does not necessarily relate to skateboarding in any way, as the intention has always been to present personal artwork by artists who happen to be skateboarders, whatever form that artwork may take, rather than to try to manufacture something stereotypically 'skateboardery', which would not be authentic or a fair representation of the scene. Therefore this book is a veritable melting-pot of fine art, low art, illustration, sketches, doodles, graphic design, street-based art, installation and everything else in between.

The fact that artwork by skateboarders doesn't directly relate to skateboarding, as such, has foxed some of those outside the skateboarding community, who seem to expect to see board graphics or back-to-back graffiti. Some of the artwork here may well fall into their perceived view of what they probably call 'skate art', but there will be a wealth of work that won't. I hope that the *Concrete to Canvas* books will help to dispel any preconceptions and generalizations about skateboarder art, and will open people up to the possibility that the connection between the artwork and skateboarding is something much more intangible.

There are of course some common themes, interests and inspirations amongst the artists. Artists such as Mike Giant and Kev Grey share a passion for tattoos and tattoo art. Nomad, East Eric and Flying Fortress have backgrounds in graffiti, for instance, but the artwork across the board is so varied that artwork by skateboarders is certainly not, and should not be, thought of as a genre in itself. It shouldn't be lumped together with a catchy one-size-fits-all label. By perceiving skateboarder art as a one-dimensional entity, only focusing on a single aspect – for instance, the graffiti element – you overlook so much other fantastic artwork being produced.

It is predominantly the creativity that links these artists: the desire and need to create. Skateboarders are historically a community of creators, doers and DIYers. In the seventies, they were constructing their own boards from old clay-wheeled roller-skates. In the eighties, the DIY spirit combined forces with the punk rock ethic, and skaters were making their own skate and music zines, badges, stickers, artwork and even skate companies.

As a young teenager in the eighties, artist Thomas Campbell started off making his own zines, forging contacts and friendships with like-minded souls. This community of artistic skateboarders grew organically out of a passion for skating and creating, on and off a skateboard. A lot of those artists/skateboarders began working within the industry for magazines and skate companies, moulding and developing it for future generations, as well as inspiring others with their personal artwork.

Skateboarder artists of all disciplines could also be seen to be part of one of the biggest art movements in the world, as Thomas Campbell explains:

> The number of artists within skateboarding from all areas – filmmakers to painters to photographers to graphic designers – make it probably the largest collective art movement in the history of the world. What else other than skateboarding is collectively tied together, has more people and a longer history of doing something, which is spawned from the same nucleus?

Not every artist I sought to include here was contactable, or able to contribute, but again, as I said in the first book, this project was never meant as a complete guide to skateboarder artists and their art. Mostly because of the size and format of the book (deliberately kept small for affordability), it was always intended as a snapshot into the varied and exciting work being produced by this group of people, and an introduction to those artists, rather than an encyclopaedia.

Due to the size and space limitations, again I decided to keep the introductory text for each artist to a minimum, to allow maximum space for the images as, after all, the whole point of the book is to show the artwork. The text for each artist is, therefore, meant to provide a brief insight into them and their work, but by including links to their websites, or websites that contain more of their work, it provides an opportunity to access further information.

I also wanted to include artists that had never been published before, alongside more established, recognizable names. Recent graduates (at the time of writing) such as David Hale and Stephen Ashton appear alongside artists who have already had entire books dedicated to their work and are highly recognizable and well-respected artists within skateboarding, such as Mike Giant, Jim Houser, Thomas Campbell and Jeremy Fish.

All that's left is to give my heartfelt thanks and appreciation to all the artists who have generously contributed their work to this book. Thanks to Stef for also contributing his design, typography and layout skills, and to Thomas Campbell for making a special image for the cover of the book. Also a big thank you to Lori Damiano for lending her distinctive voice to the Foreword. Last but not least, thank you to Chris Bourke for all of his (super-appreciated) help and support. I hope you enjoy the book as much as I have enjoyed being involved in its assembly.

Jo Waterhouse – December 2006

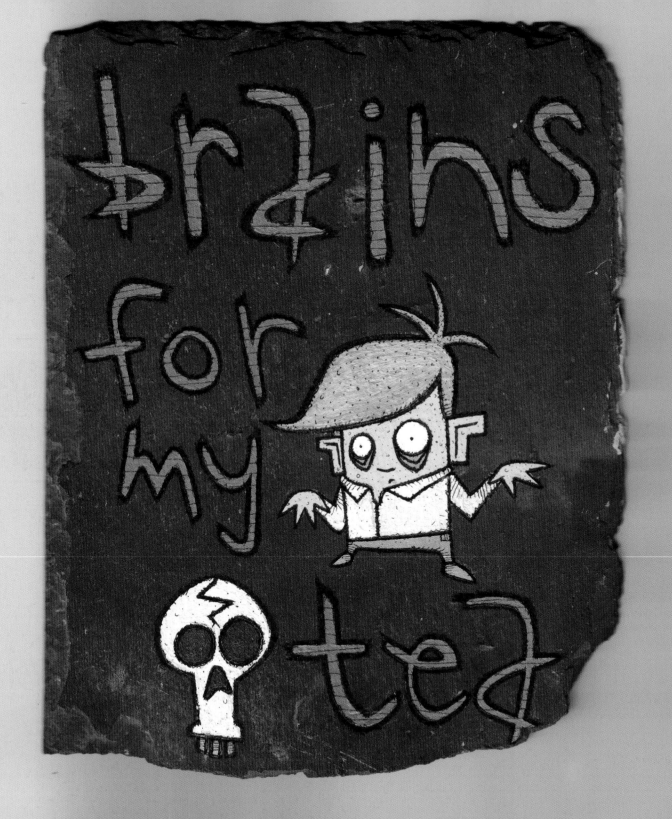

STEPHEN ASHTON

Stephen Ashton discovered skateboarding aged sixteen in his home town of Halifax, UK. He has been hooked ever since, earning himself the nickname 'Skombie' for his zombie-like obsession with skateboarding.

Skateboarding is much more of a creative outlet for me than an artistic inspiration, and though I am inspired by riding my skateboard, this is not directly reflected in my work. It is definitely true to say that my life would not be the way it is now if I hadn't started skating; I love it so much. The best thing about both art and skateboarding is that you have so much freedom and control. You can do whatever you want, wherever you want really. It's just up to you how far you want to take it and push yourself.

Stephen studied at the Cambridge School of Art and his artwork is predominantly character-based. Whether zombies, people, creatures or monsters, he focuses on developing strong character traits, and works on making his creations stand out and look unique.

I use many different materials ranging from pencils and paper, inks and watercolour, and acrylic paints, making plush toys and computer-generated images. Just whatever is close to hand, it's all fun. I tend to go through phases of preferring different ways of working: at the moment I'm getting back into doing things the old-fashioned way and just drawing, rather than getting tied up in front of a computer.

Stephen is a member of the Herald Lifestyle Crew, a Leeds-based arts collective, skate team and clothing company. They have hosted several art shows in and around Leeds and also arranged a travelling exhibition of hand-painted skateboards that toured skate shops in the UK.

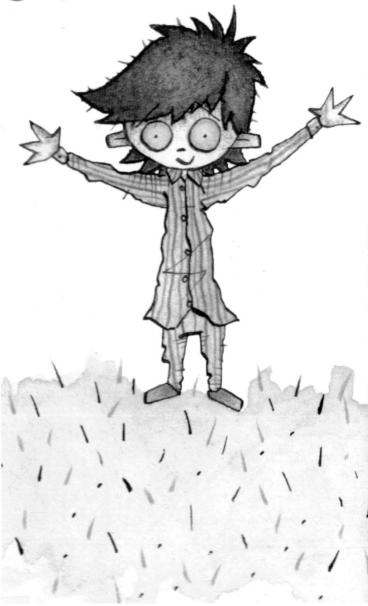

This Page
Pajama Boy, watercolour, ink and pencil crayon.

Opposite Page
Brains for My Tea, household paints and permanent marker.

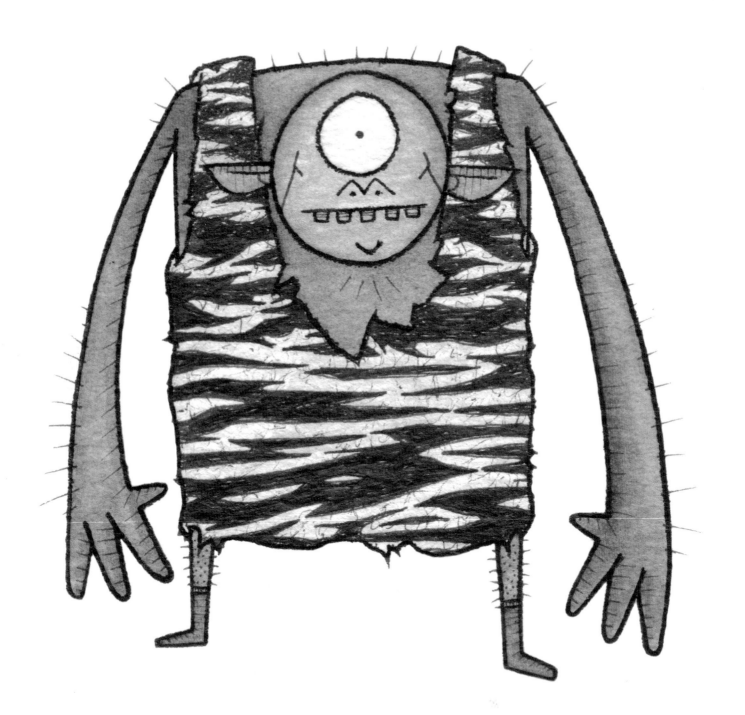

In the Land of the Blind ... This Man Would Still Be Stupid, pen and ink.

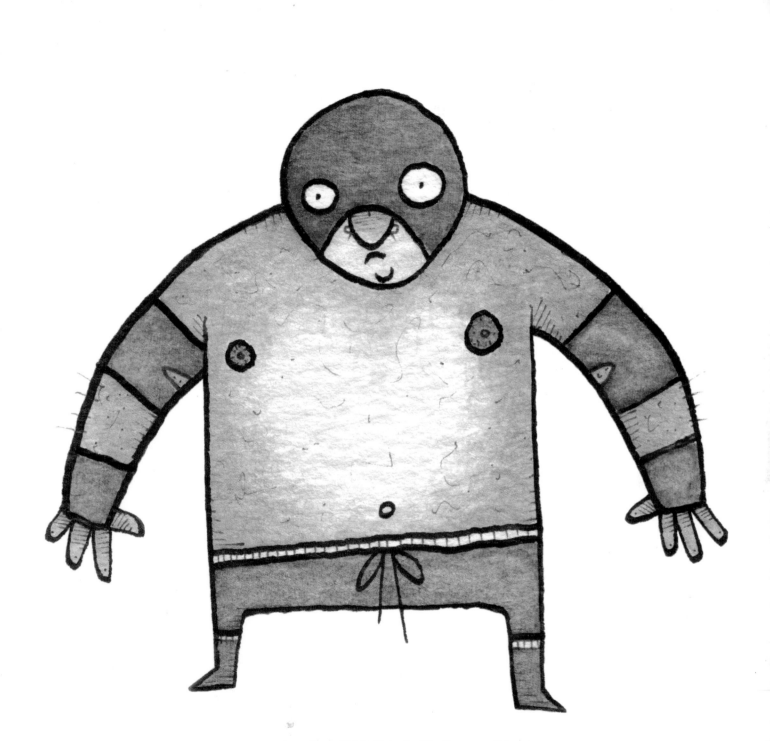

The Super Heavy Weight Champion Wrestler, pen and ink.

LEE BASFORD

www.meisai.ne.nu
www.fluidesign.co.uk
www.outcrowdcollective.com

Lee Basford is a Birmingham, UK-based artist and designer. His commercial design work, as Art Director at Fluid, has resulted in him designing for well-known video game, fashion and music companies, such as Sony, Capcom, EMI and Parlophone. His work has also been featured in several magazines, books and design journals.

> I think because I work in a high pressure, tight deadline-led design industry, using a computer quite a lot, my work outside of that tends to be a lot more handmade. Finished pieces emerge from the organic growth and exploration of an initial idea and its possibilities. I'm always looking for happy accidents, mostly without the use of an 'undo' key. Much of the work is created quickly, with whatever surface and materials are around or can be easily accessed, which at times can be a guiding force in the outcome of the work.

Lee has been skating since 1987 and skate culture has been a big influence on his life and art:

> I was totally immersed in skateboard culture from the age of twelve onwards. I was already interested in art and design, so that side of the culture had a huge influence on me while my artistic and musical tastes were still developing. The outsider attitude of being apart from the mainstream is something I think all skaters share, and hopefully never lose. Artistically, I was hugely influenced by skate magazines, especially *Homeboy*. The dynamic trio of Andy Jenkins, Spike Jonze and Mark Lewman gave me the inspiration to design, photograph, write and skate. The whole culture seemed to merge together into one perfect entity with that magazine. It pointed me in the right direction on many levels.

Lee exhibits his personal work as part of the Outcrowd Collective, and in 2006 had a joint show with Andy Votel in Shibuya, Tokyo.

We Took Our Broken Dreams,
skateboards, found wood, nails, wax, paint, glue.

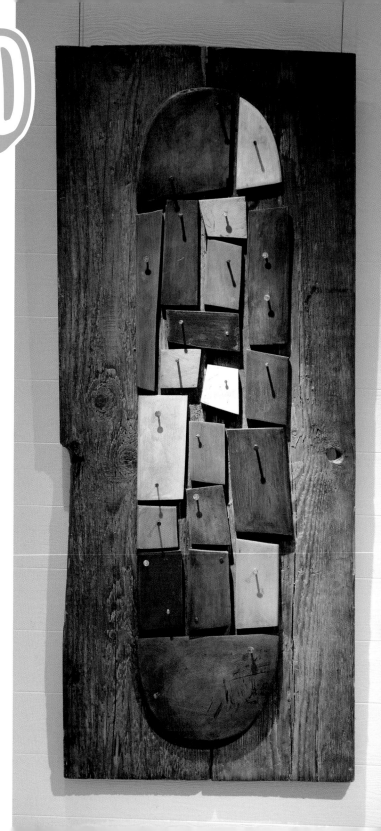

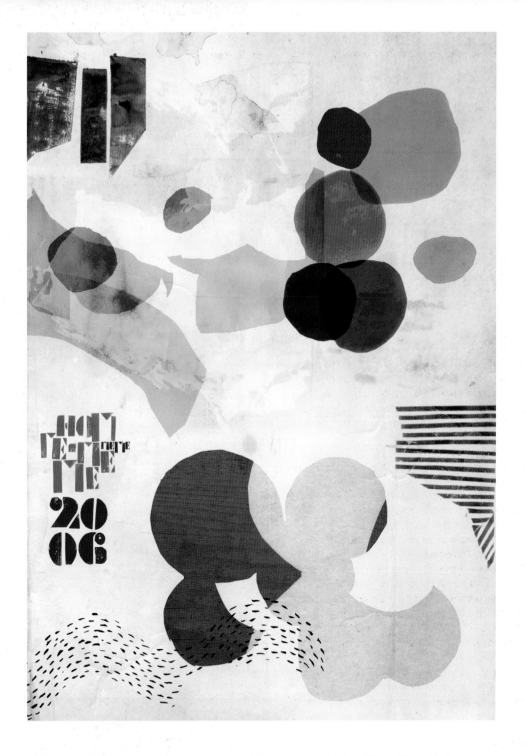

Meme exhibition poster, cut-out wooden type and shape stamps, printed on Hahnemühle archival paper.

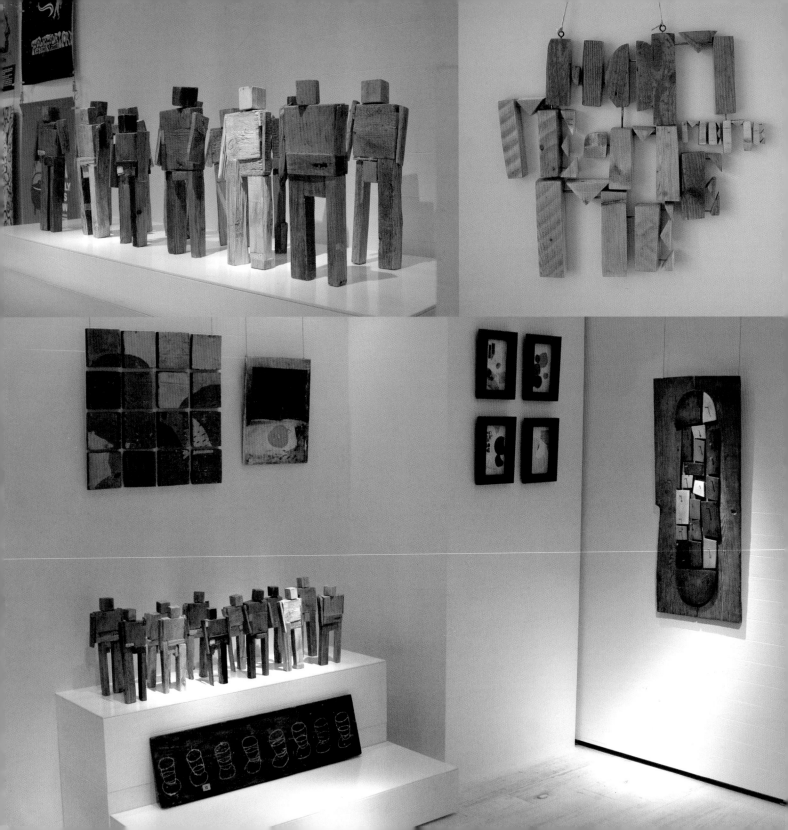

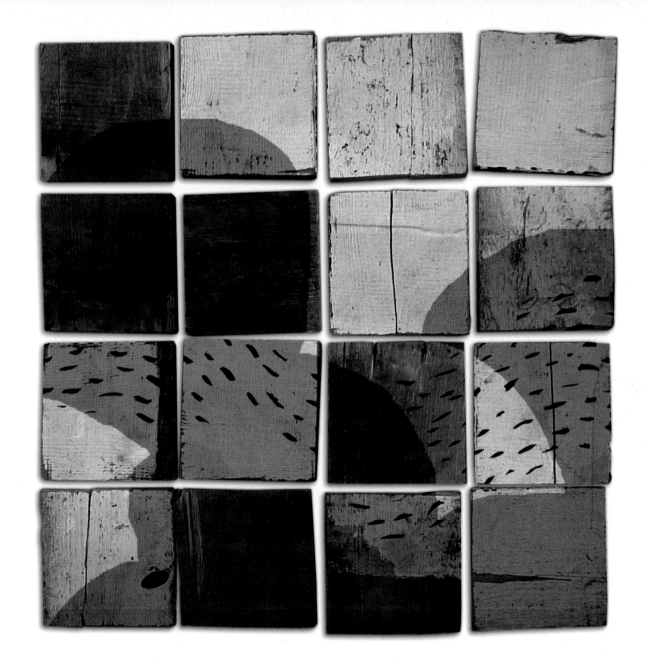

This Page
4x4 Squares, found wood, paint, varnish.

Opposite Page
Top left: ***Perpetual Disappointment***, found wood, nails, glue, wax, paint.
Top right: Meme sign, found wood, steel rods, glue, old hooks and chain.
Bottom: Exhibition overview, Adam et Ropé store, Shibuya, Tokyo.

THOMAS CAMPBELL

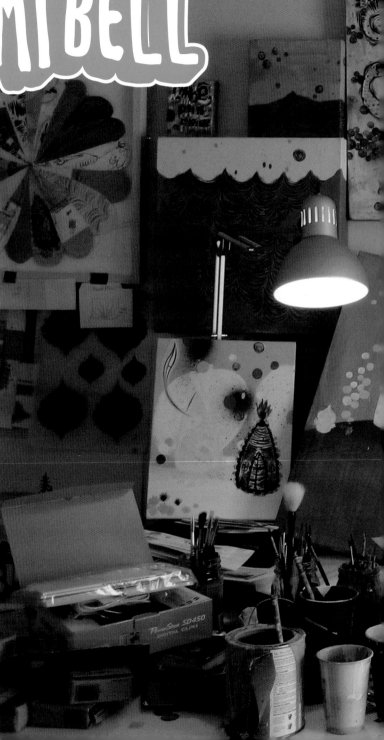

www.thomascampbell-art.com
www.galaxia-platform.com

Thomas Campbell is a California-based artist whose work encompasses photography, paintings, drawings, sewn collages, wooden structures and, most recently, bronze sculptures. These different elements of his work are often fused together, generating intricate mixed-media creations. His paintings combine a unique blend of figurative, fantasy and expressionistic qualities, with a cast of instantly recognizable characters, often accompanied by snippets of thought-provoking text, and the lines in his paintings and drawings always infer a sense of movement and reverberation.

Thomas has been skateboarding since he was five years old, growing up in southern California in the skateboarding boom of the seventies. As a young teenager he was inspired by the creativity within skateboarding:

> At that time we had really great examples of creative mentors like Todd Swank, Neil Blender and Andy Jenkins. These people – their lives – were taking pictures, drawing, painting, making graffiti, making movies, making fanzines, making music. That was all really normal if you were a skateboarder to do that. Honestly, without being a skateboarder, or being from that culture, I can't imagine doing anything that I do now.

Following their lead Thomas set out down his own multi-faceted creative career path that has included being a staff writer, editor and photographer for US skate magazines *Transworld*, *Big Brother* and *Skateboarder*, as well as skate magazines abroad. He has made two feature-length movies about surfing, *The Seedling* and the more recent *Sprout*. He has produced skateboard graphics for Toy Machine, Zero, Stereo, Santa Cruz and S.M.A, as well as designing album covers for his independent record label Galaxia, producing music and releasing records by skateboard legends Tommy Guerrero and Ray Barbee, amongst others. Thomas has also exhibited his artwork widely in solo and group shows across the US, Europe, Australia, Africa and Japan.

Studio view: 'Inside doodle station at home for detailed work and sewing', Santa Cruz, California.

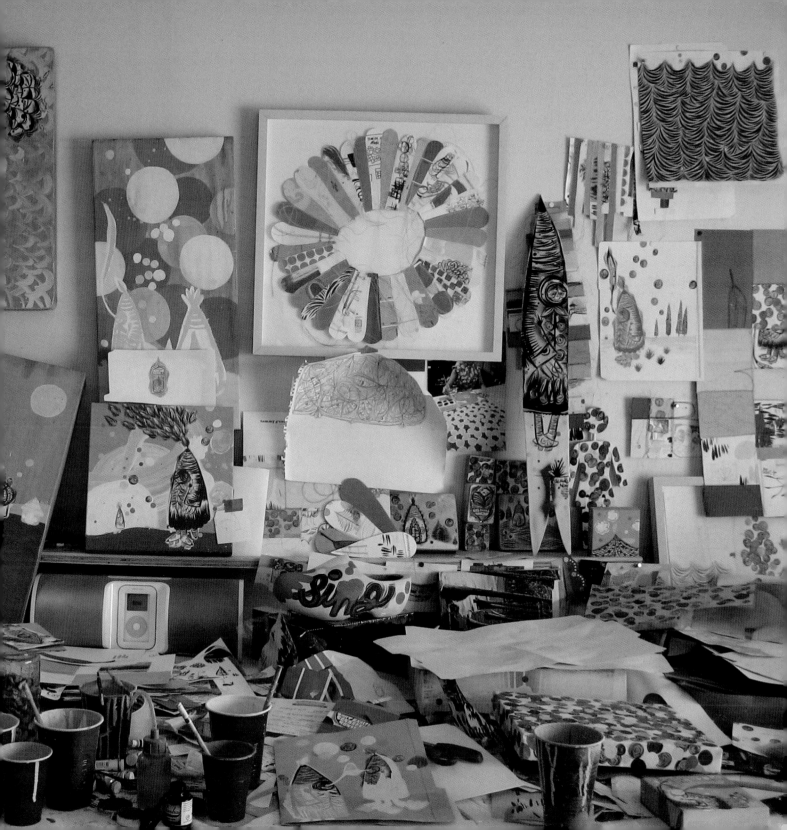

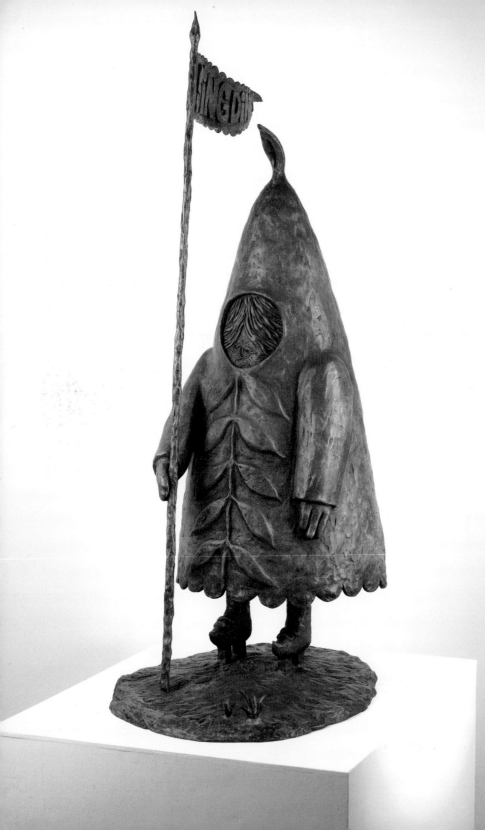

Sing Ding Aling, bronze, 2nd of 6 sculptures.
Photo: Jeff@MG Imaging

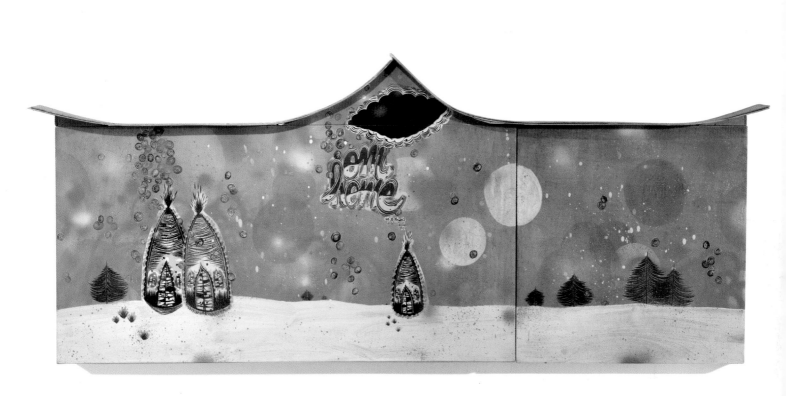

Om Home, acrylic, spray paint, gouache, india ink on wood and canvas, with a roof.
Photo: Jeff@MG Imaging

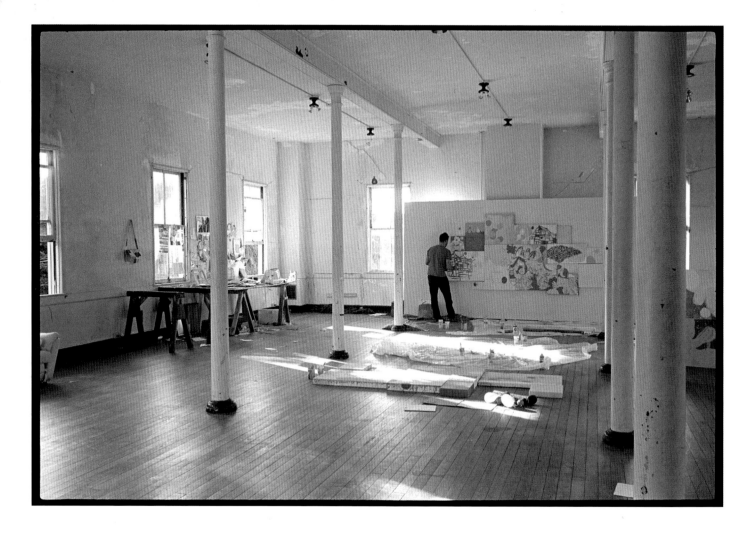

'T.moetucker, dork at work', Headlands Center for the Arts, Sausalito, California.
Photo: Mark Whiteley

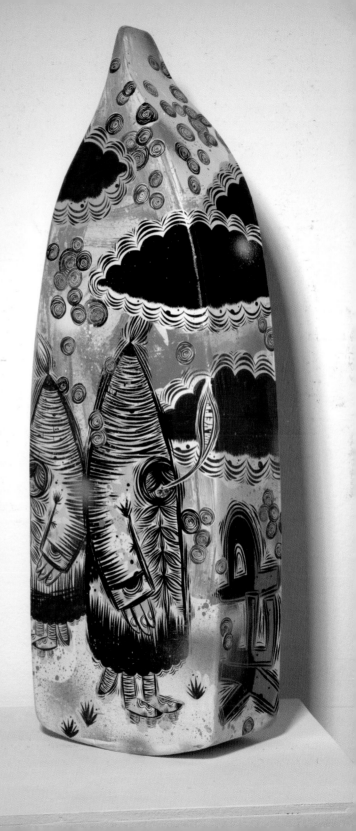

Above: *Fauna*, gouache, india ink, pencil, sewing on manila folder.

Right: *Webble #1*, recycled skateboards, acrylic, spray paint gouache, india ink.

Photos: Jeff@MG Imaging

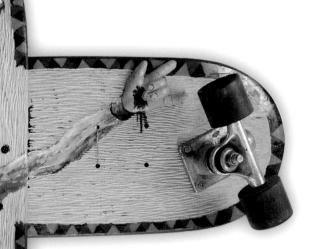
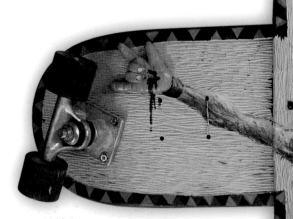

This Page
Skateboarding is a crime, mixed media.

Opposite Page
Left: **Skateboard 01**, paint on old school skateboard.
Middle: **Skateboard 02**, paint on old school skateboard.
Right: **Simran**, paint on skateboard.

CHRIS DYER

Chris Dyer grew up in Lima, Peru. When he was seventeen he moved to Canada where he developed his interest and passion for art, skateboarding and travelling. Chris describes his artwork as 'Visionary Skate Art', which he creates with used and broken boards as canvasses. Creating his art is a soulful process for Chris, whose vibrant paintings are reflections of his positivity, spiritual beliefs, and love for life:

Skateboarding inspires my art by its great unique energy; a physical expression of the fire we have to fly and challenge the laws of physics. The same is with art: skate magic gets in. Especially when I do graphics over boards that have been broken after some use. The energy of the person filters into that wood after meditating on it so much. That's why I like to paint on boards from my Pro friends, because the expression that floats up naturally comes out quite Pro as well.

Chris mostly uses acrylic paint but also likes experimenting with other media such as oil paint, watercolours, pastels, markers and digital media. He was hugely inspired by skateboard graphics of the eighties, in particular work by Jim Phillips and the neon bright Vision graphics:

That's why I try to make my work so detailed and colourful, but with my own personal message.

Chris has designed board and T-shirt graphics for Creation Skateboards and Satori Movement, and board designs for Think Skateboards.

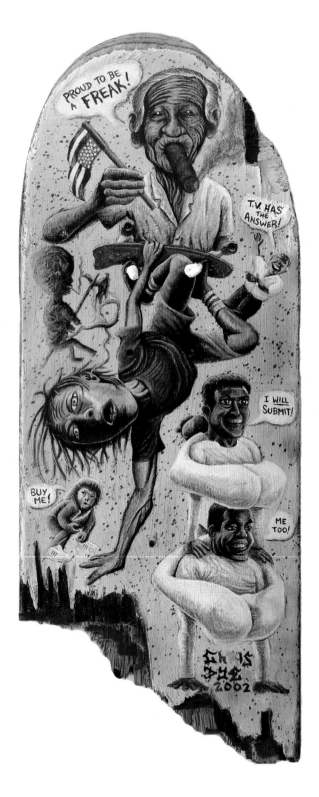

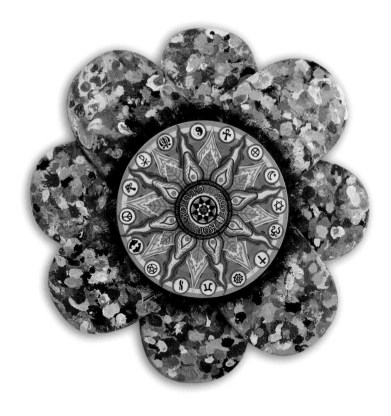

This Page
Above: *Flower*, acrylic and oils on broken skateboards.
Left: *Proud to be a freak*, ink and acrylic on broken skateboard.

Opposite Page
Skateboard 36, ink and acrylic skateboards.

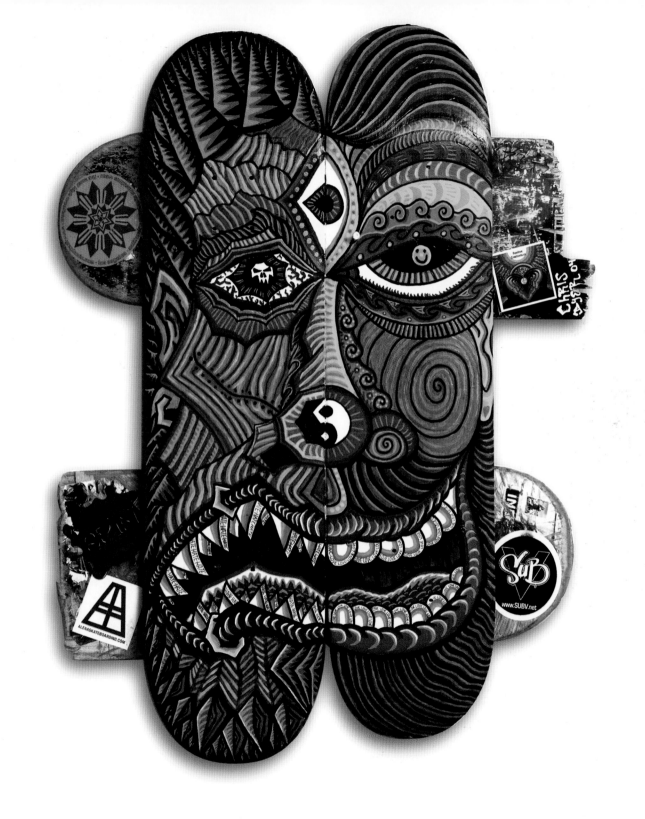

EAST ERIC

East Eric from France describes himself as a polymorphic artist due to the extremely varied nature of his work. He likes to:

> ... experiment in new fields by intersecting diverse techniques. I'm interested in video, painting, sculpture, installation, performance, politics, poetry and the semantics of things.

His work often has a political, controversial and outlaw edge and includes projects such as doctoring large billboard advertising posters, painting a tank pink, body painting using semi-naked ladies as a canvas, spraying an entire toilet cubical gold (including the toilet and bowl), making edible weapons such as knuckledusters and knives moulded from candy, creating an army of ants all over the city streets by converting a child's bike into a mobile street stamp and putting Che Guevara T-shirts onto large roadside crucifixes. Other installation projects include painting an entire Smart car gold – windscreen and all – that was parked in the street, painting a van all over in bright green polka dots and covering a car in leaves until it was barely visible.

The anti-establishment nature of his work, which he describes as its 'rock 'n' roll spirit', is most likely a direct result of being influenced by, and immersed in, skate culture. He crosses literal and metaphorical barriers of all kinds with his art and invents new things by mixing together places, ideas, shapes and colours.

East Eric is of Polish and Algerian descent and he believes you can find his 'extreme cultural crossbreeding' in his artistic and textile work.

Ultimate One Spray Budget Whole Car Tuning, mixed media.

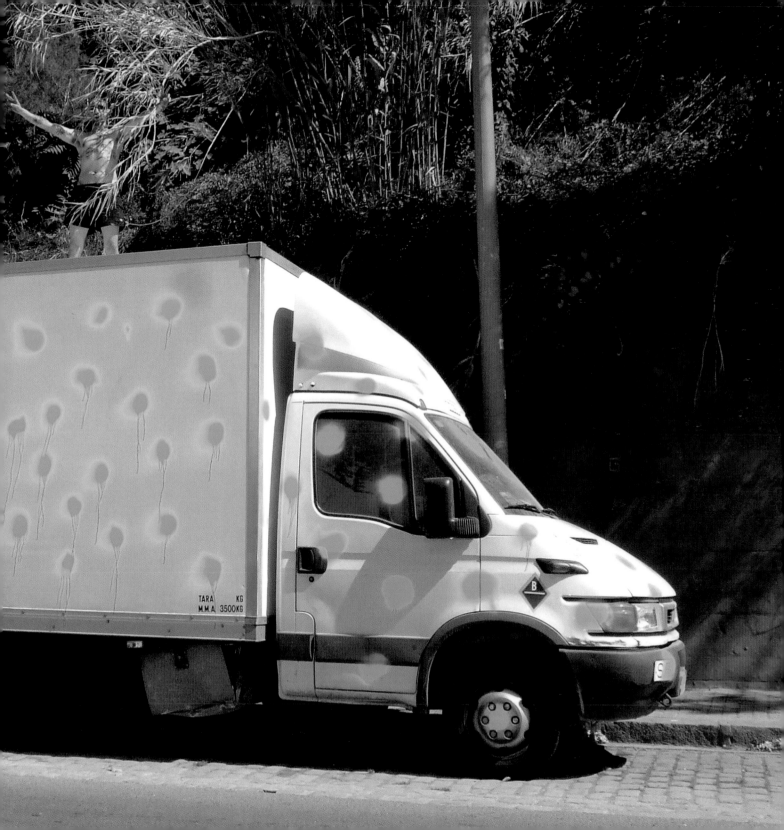

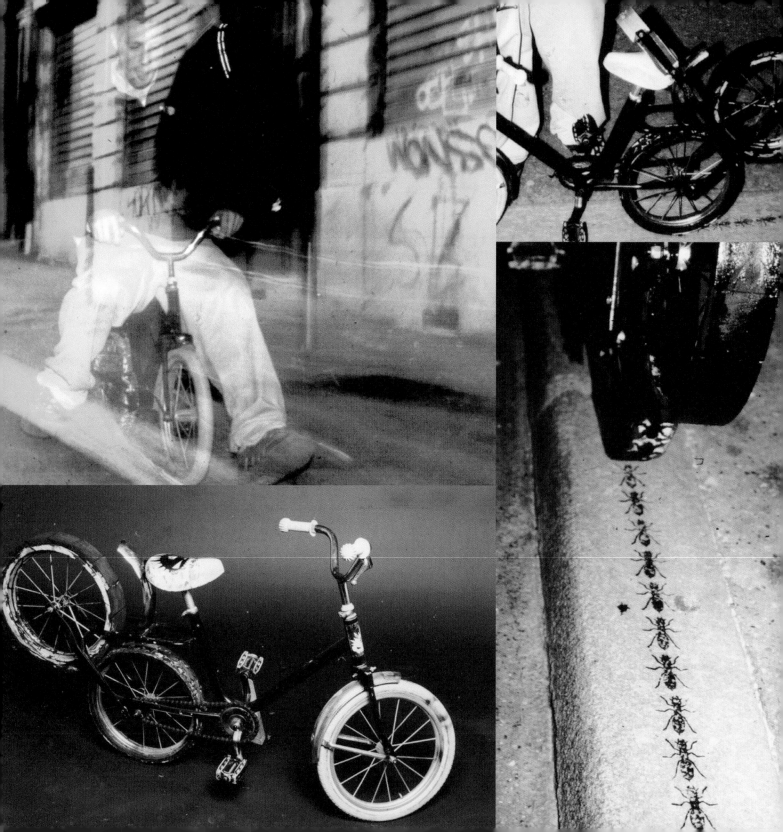

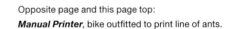

Opposite page and this page top:
Manual Printer, bike outfitted to print line of ants.

This page, middle: **Arthropoides Nexus**, ant toy/spray paint can.

This page, bottom: **Rojo (Carmina) Burana 'Tribute to Buren'**, ant wallpaper.

EKTA

www.fotolog.com/ekta
www.orosmoment.com

Ekta got his first skateboard from a second-hand shop in his native Sweden in 1986, aged eight. He has been skating ever since:

> I've always been drawing, and after discovering skateboarding I would draw a lot during the winters or when it was raining. I made my first comic zine in 1989.

His early influences were the artistically inclined Pro skaters Gonz and Neil Blender. To Ekta, watching them skate was like watching artists at work:

> Just like when someone like Coltrane is improvising jazz, he 'paints'. When those guys skated they would 'paint', like Gonz in the *Real* videos or *Video Days*. I love that!

Ekta moved to London in 1997 and spent eight years studying, working, skating and painting. A foot injury put skateboarding on the back burner for quite a while, which meant Ekta had more time to spend painting and drawing. He utilizes acrylics, pens, markers, spray paint and mixed media in his work. In 1999 he took up painting and pasting up in the streets:

> I like the idea of decorating and changing the city, altering useless architecture and turning it into a playground or gallery. I got into reading a lot about the Situationists, and found that their theories are very close to the practice of skateboarding and street art.

In 2005 he moved back to Sweden to start the ORO gallery with eight fellow Swedish friends and artists.

Suave Loathing, paste-up and paint on a wall.

31

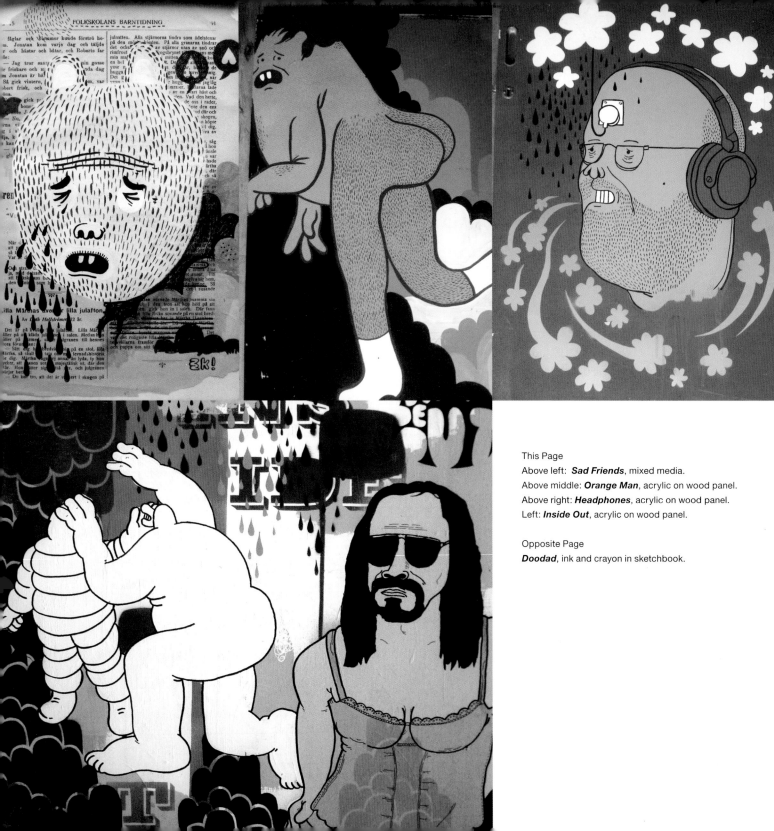

This Page
Above left: **Sad Friends**, mixed media.
Above middle: **Orange Man**, acrylic on wood panel.
Above right: **Headphones**, acrylic on wood panel.
Left: **Inside Out**, acrylic on wood panel.

Opposite Page
Doodad, ink and crayon in sketchbook.

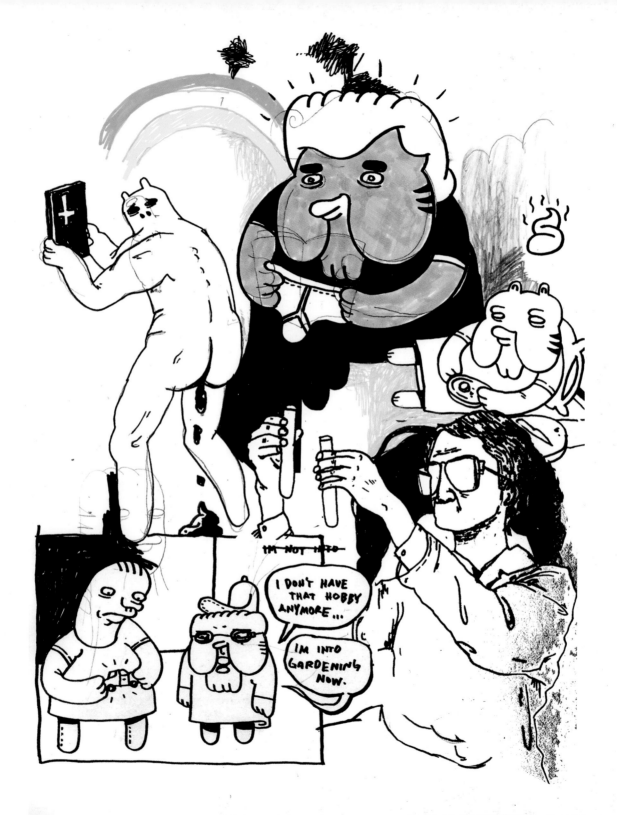

FERNANDO ELVIRA

Fernando Elvira was born in the Basque autonomous region of Spain. He grew up in a very creative family: his grandfather was a graphic designer and painter and his father is an accomplished oil painter. Fernando initially studied chemistry at the Universidad Autónoma de Madrid but left the course to run *Tres 60*, a skateboard magazine with national distribution.

Following that he decided to become a full-time artist. His artwork encompasses photography, using 35mm and Polaroid film, found objects such as wood, bones and teeth, graphic design, installations, sculpture and journal keeping. However, he is probably most well-known for his collage style, using adhesive paper to produce striking, handmade, cut-out images, creating a completely unique visual language that is distinctively his.

My work is raw, bold and executed in a very simple way. I do not use computers at all. It has taken me over 30 years to reach this level of simplicity, directness and personal style.

Fernando has produced numerous skateboard graphics for companies such as Cliché, Alai and Sugar Skateboards.

Skateboarding was my first love and also my first job, and it means to me self-expression, freedom, rebellion, creativity, travel and great friendships. My five all-time favourite people to skate with are: Eduardo Saenz, Thomas Campbell, David Aron, Javier Mendizabal and Alfonso Fernandez 'Lute'.

Espiritual Carnal, Candle installation.

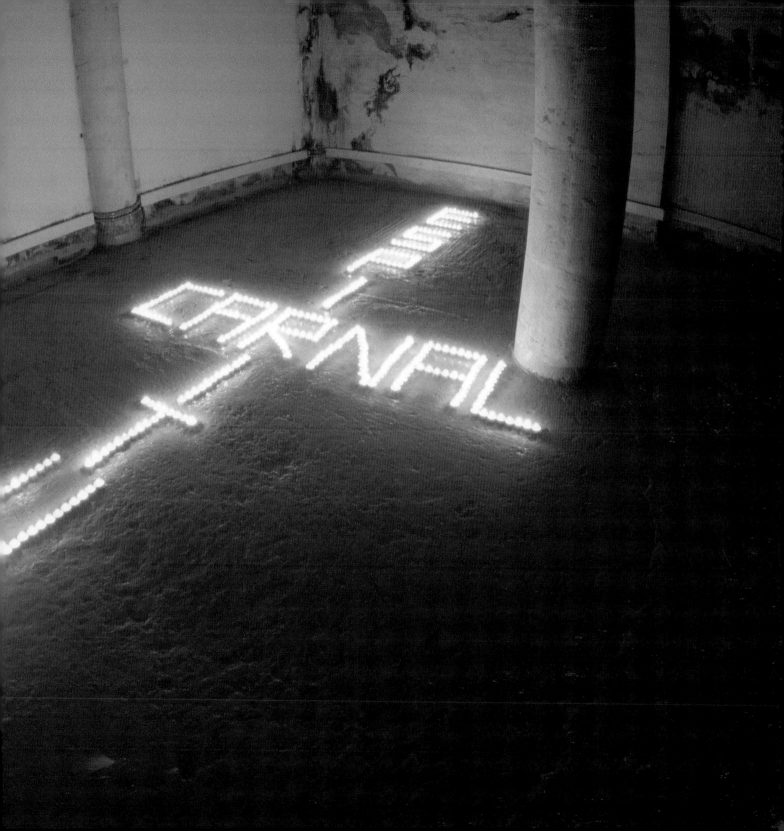

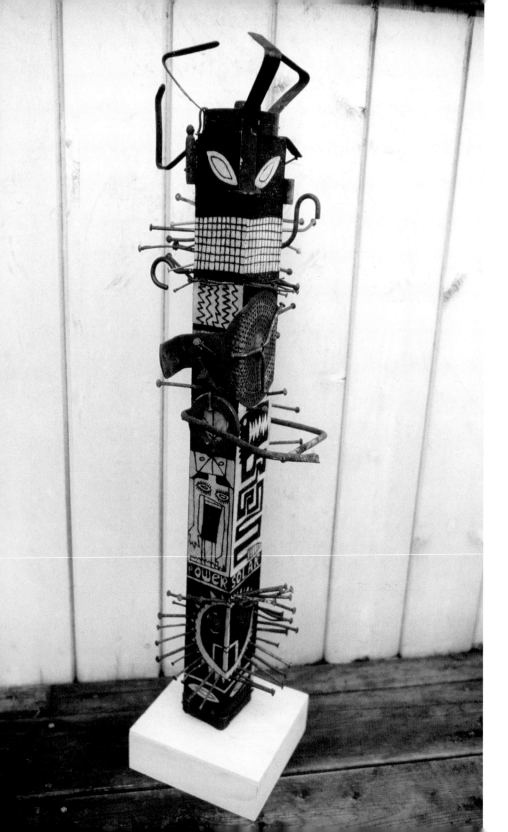

Power Solar, Magnifying-glass-burnt drawing,
wood and metal.

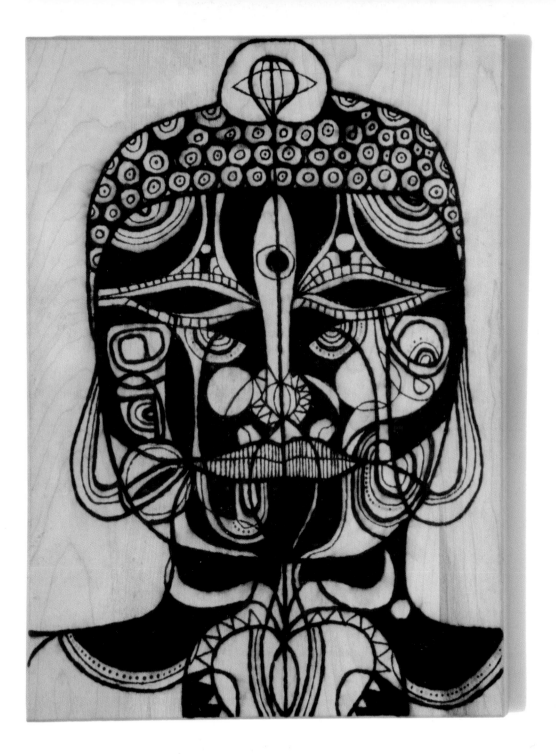

Buddha, Magnifying-glass-burnt drawing on wood.

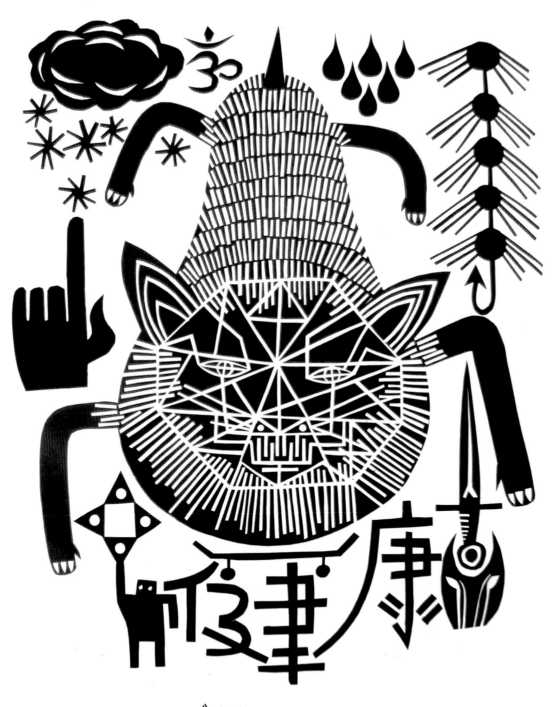

"伎津床", stickerpaper on paper.

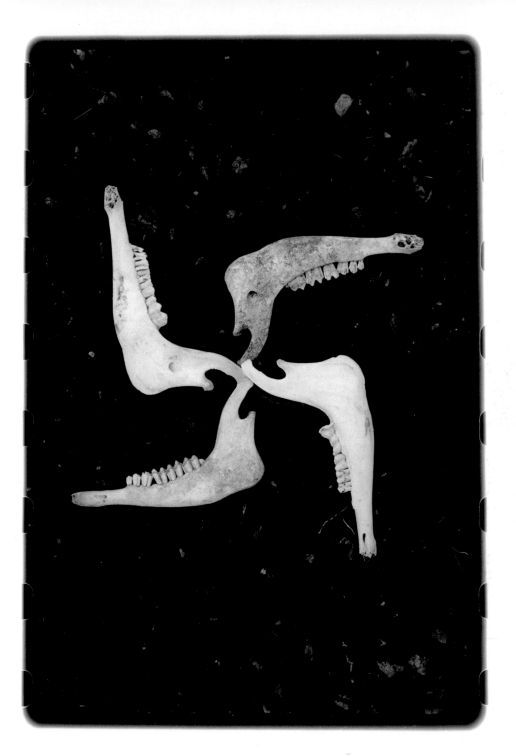

Jawastica, black-and-white photograph.

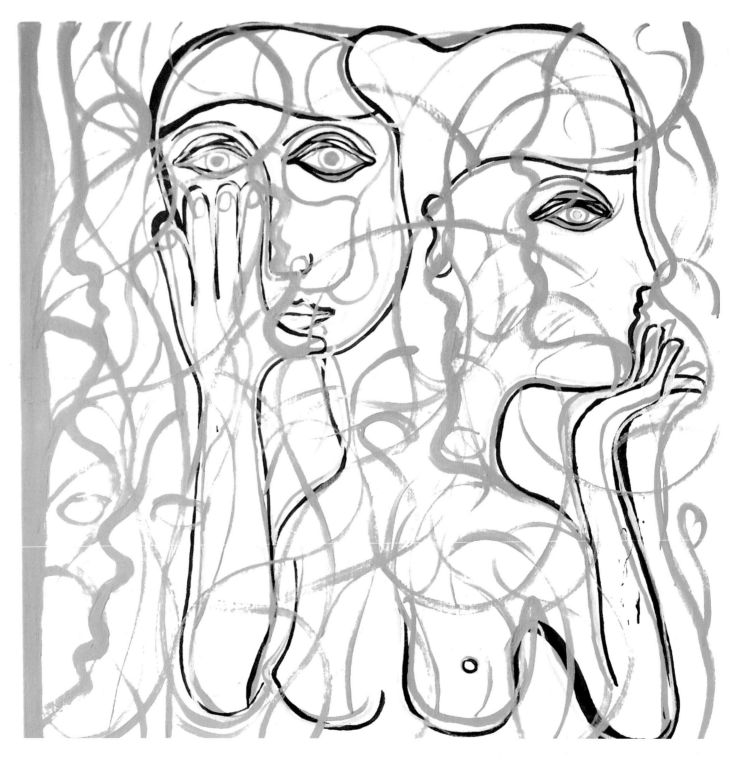

Twins, acrylic on canvas.

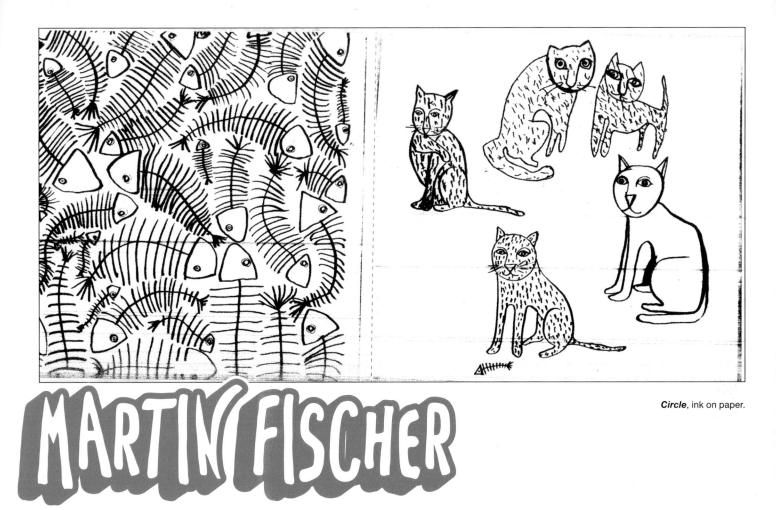

Circle, ink on paper.

MARTIN FISCHER

www.fisheye.cz

Martin Fischer is a freelance graphic designer and illustrator from Prague.

In the mid nineties I skated the legendary Stalin skate spot when the marble edge was sharp and new and the local crew had no idea that skateboarding could, and would be, way more than just a bit of fun.

After finishing studying art he spent a few years running his own creative shop called Stereo*com. He has since become a freelance designer who for the past five years has created the visual look of Prague's famous annual skate competition, The Mystic Sk8 Cup. His commercial work also includes collaborations with the US clothing company Volcom on graphic design projects.

Volcom was behind his first solo exhibition *The Unfinished Dreams*, in Hossegor, France. This show joined the Volcom *Unstable* show and travelled across Europe in select skate shops with a group of Volcom-supported artists including Ozzy Wright, Ben Brough and Pierre Marre.

Martin uses a combination of analog and digital techniques. Hand-drawn sketches, computer graphics, or images from his digital camera travel through fax machines or copy machines, or are produced on canvas or screen printed. Whatever the combination of techniques and media used, he will create a unique, final piece with his characteristic line drawings and gritty montages.

He has recently completed his first limited-edition handmade book *Fax You*, which is a collection of images taken from a 'drawing duel' with fellow artist Masker, and printed on thermo paper via fax machines.

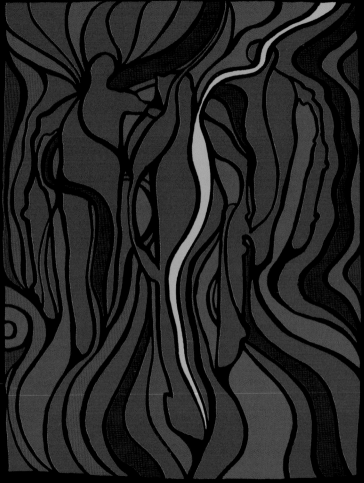

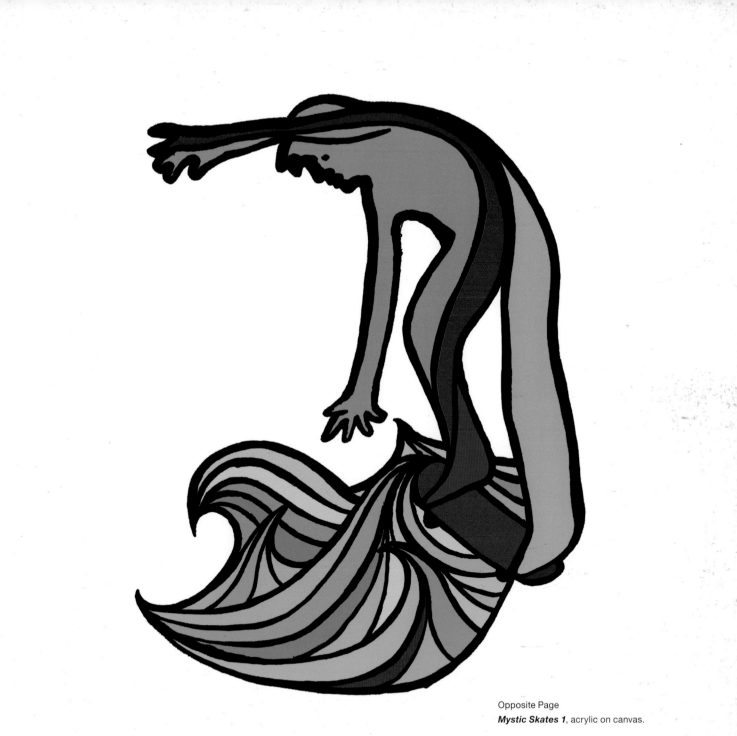

Opposite Page
Mystic Skates 1, acrylic on canvas.

This Page
Mystic Skates 2, acrylic on canvas.

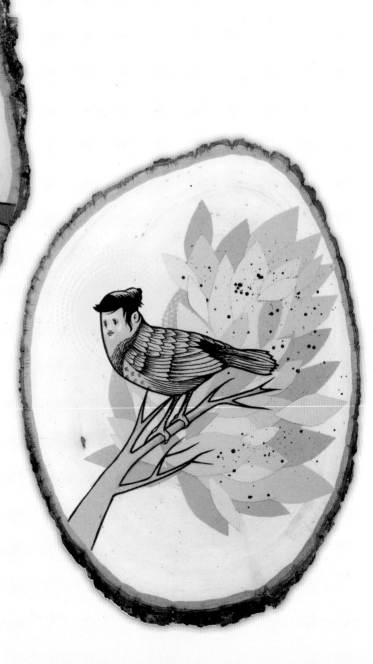

This Page
Above: *That Bird*, mixed media.
Right: *This Bird*, mixed media.

Opposite Page
The One That Got Away, mixed media.

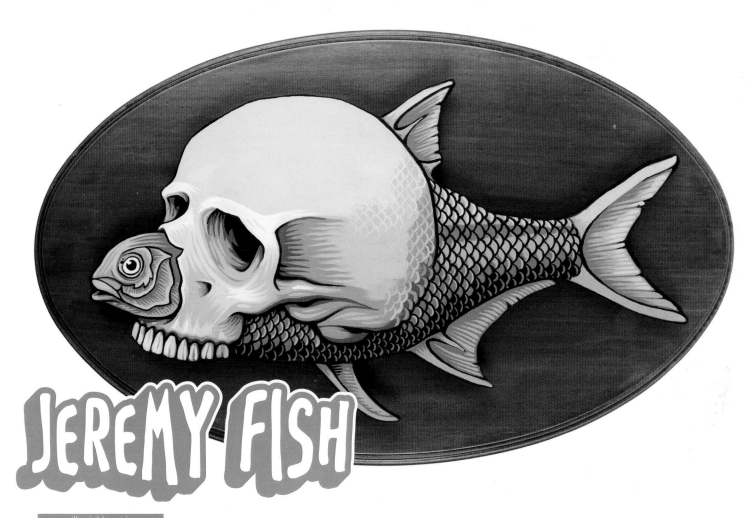

JEREMY FISH

www.sillypinkbunnies.com
www.umbrellamarket.com

Jeremy Fish is originally from upstate New York, but he moved to San Francisco in 1994 to attend the San Francisco Art Institute and graduated four years later with a Bachelor of Fine Arts.

Jeremy started skating at a young age and his initial artistic inspiration came from skate graphics:

> Skateboarding has made me who I am. It got me interested in art through staring at board graphics in the shop I worked at in high school. Long winter days with no customers, and just me staring at all the cool drawings on the bottom of the boards.

He went on to work for Think Skateboards as an art director, being responsible for all the art concepts and illustration for boards, wheels and T-shirts from 1999 to 2001. He was also the co-owner and art director of The Unbelievers skateboard company with Scott Bourne.

In 2005 he had a book of his work published called *I'm With Stupid*; it included examples of his paintings, drawings, board graphics and his series of illustrations for *Slap* magazine, 'The Big Stupid', which ran from 2001 to 2004.

He describes his work as 'little stories told with symbols and characters' and his preferred medium is pen and paper. He has exhibited across the US, Europe and Australia.

> I celebrated 20 years of skateboarding last year on my thirty-first birthday. I spent that day at general hospital having my ankle sewn back on. Proof that just because you do something for 20 years doesn't mean you are any good at it.

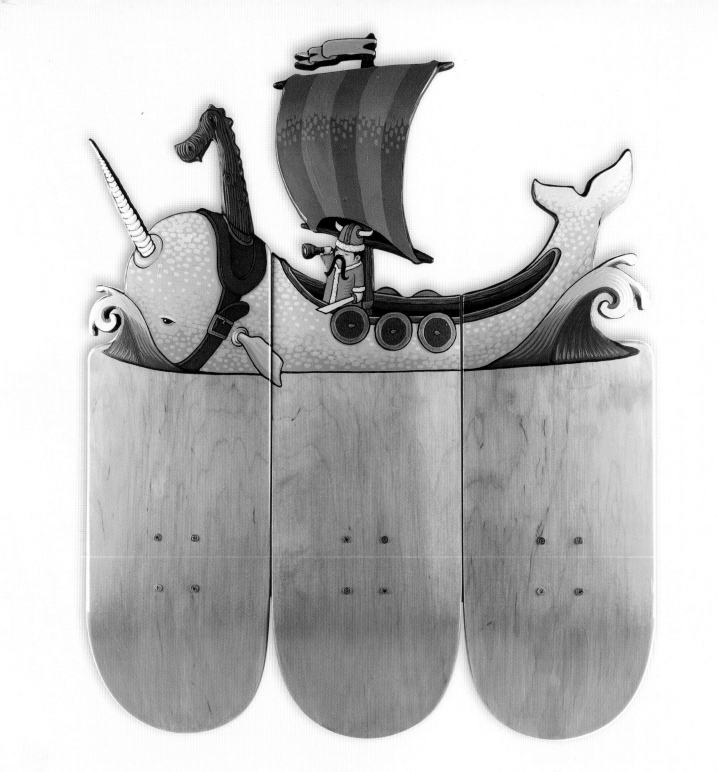

Gnarwal Ship, mixed media.

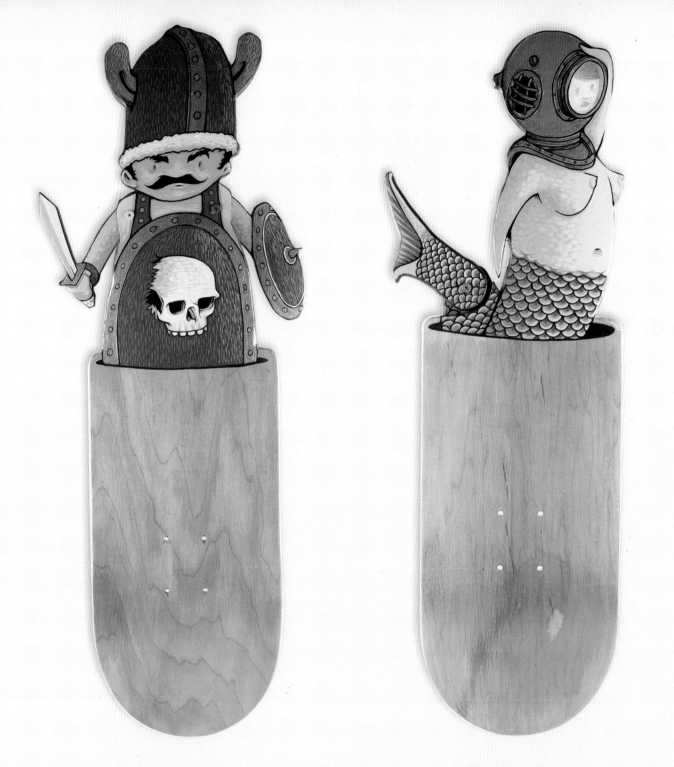

Angry Viking, mixed media.

Lost Mermaid, mixed media.

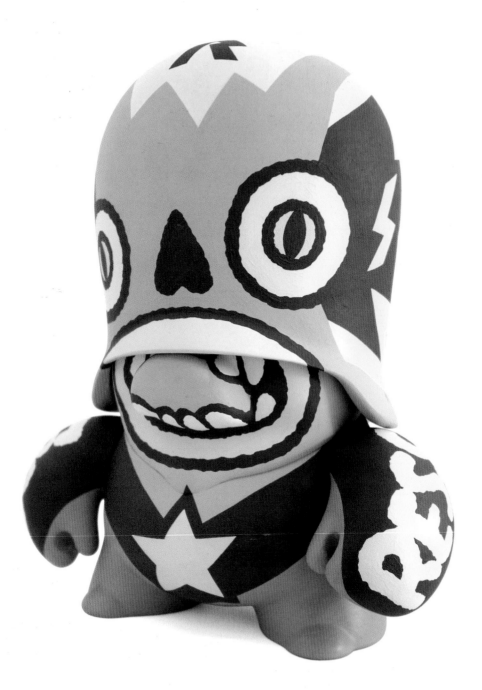

This Page
Customized Teddy.

Opposite Page
Teddy Troops vinyl toys.

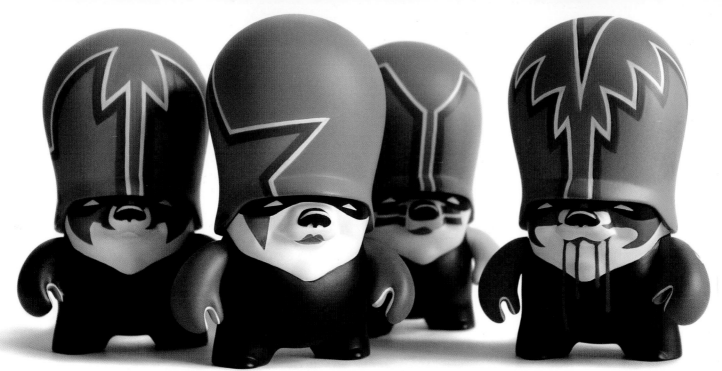

FLYING FORTRESS

www.flying-fortress.de
www.teddytroops.com
www.rockawaybear.com

German artist Flying Fortress has been slowly but surely conquering the world with his Teddy Troops.

Having started skateboarding in 1988, it was only a few years later that he was taking his first steps in graffiti.

I have been on a mission of classic graffiti since 1989, but stopped around 1995 because of getting stuck in a one-way alley – as the whole scene had been at that point and time. After studies in graphic design, I got back in the streets by sending out a proper army of my iconic 'Teddy Troops', using any kind of medium: stickers, posters, spray paint.

The instantly recognizable Teddy Troops have been infiltrating the streets right across Europe and the UK. Pieces of his work have also made it to New York, Toronto and Vancouver, and he is also planning an upcoming tour to take them to Asia.

Flying Fortress has produced work for companies such as Hessenmob and Stussy, Addict, Carhartt and Kid Robot, and continues to add to his own product line. Since 2004, his Teddy Troops have been available as vinyl toys, and he has collaborated with friends and fellow artists to produce highly desirable collectors' pieces.

Skateboarding taught me to do it my way. Try new things, alone and together. Friends, rudeness, smartness. Grab your board and skate. Grab your tool and create!

Untitled, hand-painted acrylic on canvas.

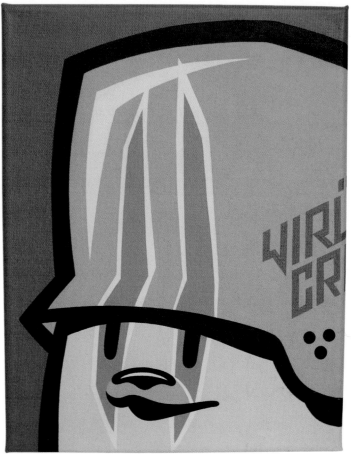

FRENCH

www.tapedcopies.com

French is an artist and illustrator originally from Aldershot, UK but now based in Brixton, south London.

He obtained a BA Honours in Fine Art from Staffordshire University and mostly uses pen and paper to create his work, but also utilizes materials such as pencil, felt-tip pen, acrylic and watercolour paint, collage and old frames from charity shops.

He started skating when he was twelve and grew up skating the underground car park in Farnborough, with a group of much older guys. He had discovered art much earlier:

> My Mum was always into art and worked at an art college so I used to see all the students' artwork and wanted do what they were doing. When people asked what I wanted to be when I was older I always said 'an artist student'. I guess I wasn't thinking it through… My first board was a Ross Goodman 'Grave Digger' – it had the best graphic. I don't think that influenced me too much then, but looking back it influences my work more now. I love the raw darkness, the gore and the crazy detail in the old boards. No one really makes such crazy graphics anymore. Graphics should be rough, dirty and gnarly.

French says his influences change and develop all the time, along with his work. He is currently really into drawings and etchings by people like Doré and Goya, and John Martin's painting – work with religious themes that depict heaven and hell.

> I'm also really into old anatomy illustrations and books of nineteenth-century magazine and newspaper illustrations. I find old horror movie posters really interesting and books about horror special effects. I get massive influences from the artists who make metal album artwork, too.

French's artwork has appeared in magazines and journals such as *IDN*, *Arkitip*, *Modart*, *Lodown*, *Sidewalk* and *Dazed and Confused*, and he has produced work for a varied list of companies including Heroin, Creature and Antiz Skateboards, ITV, The BBC, Emerica Footwear, Silas and Southern Records.

His work has also been shown in exhibitions in Europe, the US and Australia.

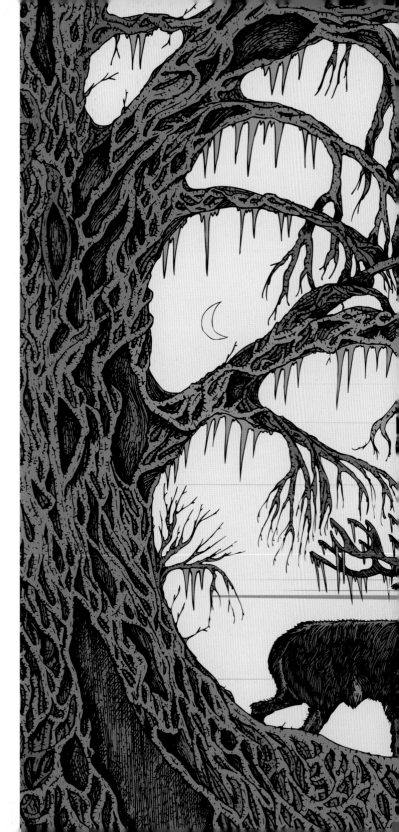

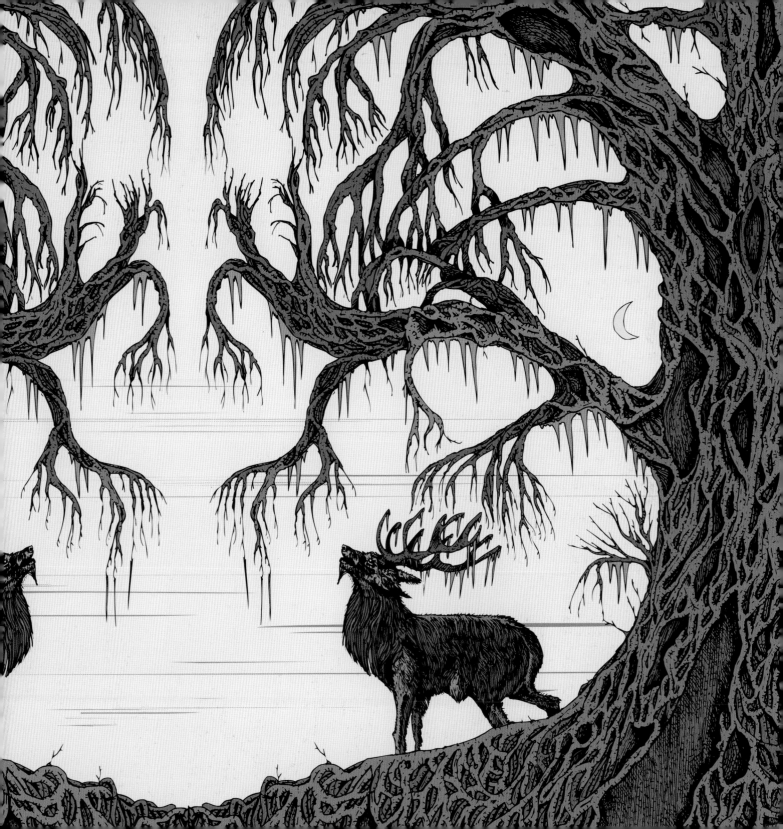

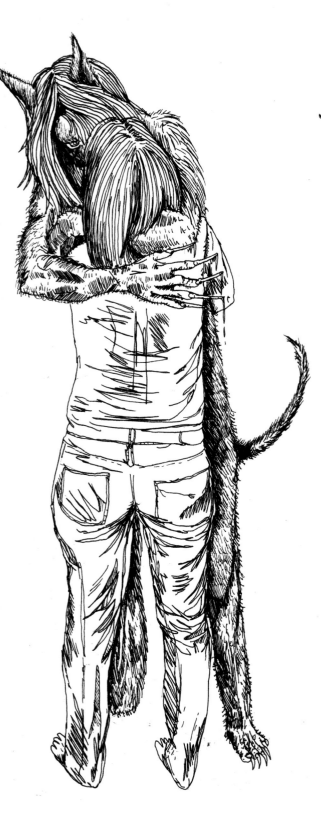

This Page
Wolf Love, pen and ink.

Opposite Page
The Sea, pen and ink.

Previous Spread
Forest, pen and ink.

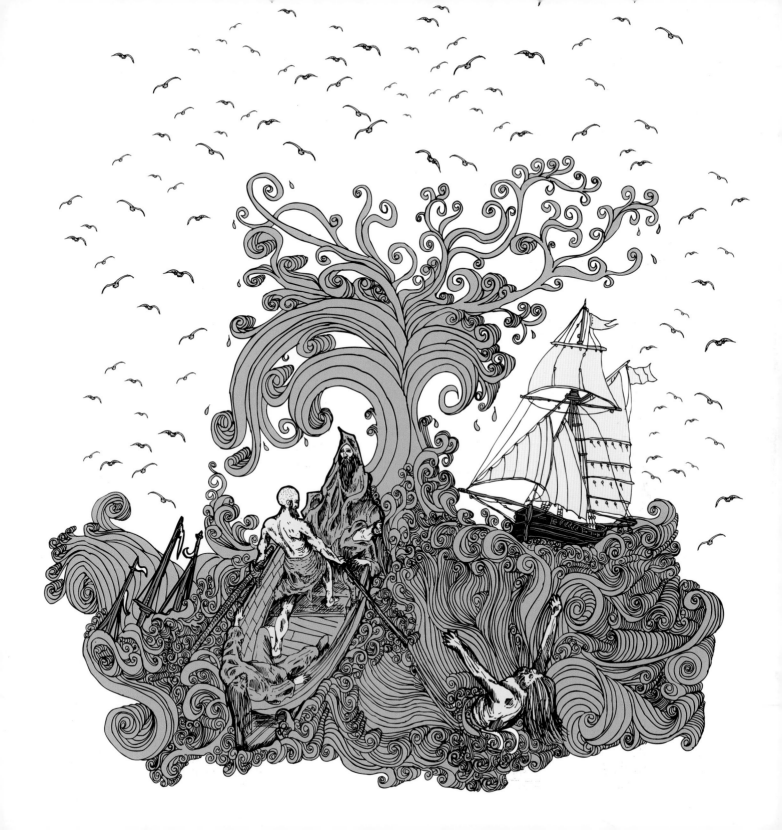

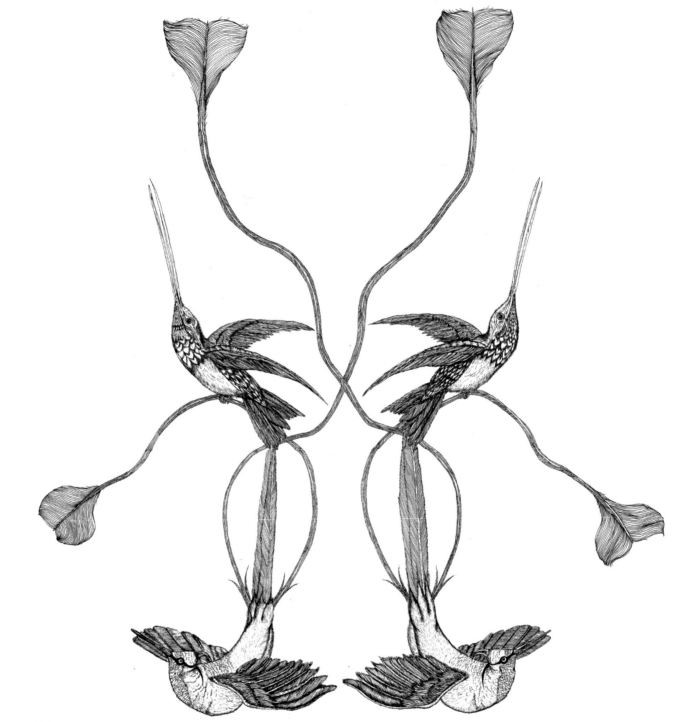

Birds, pen and ink.

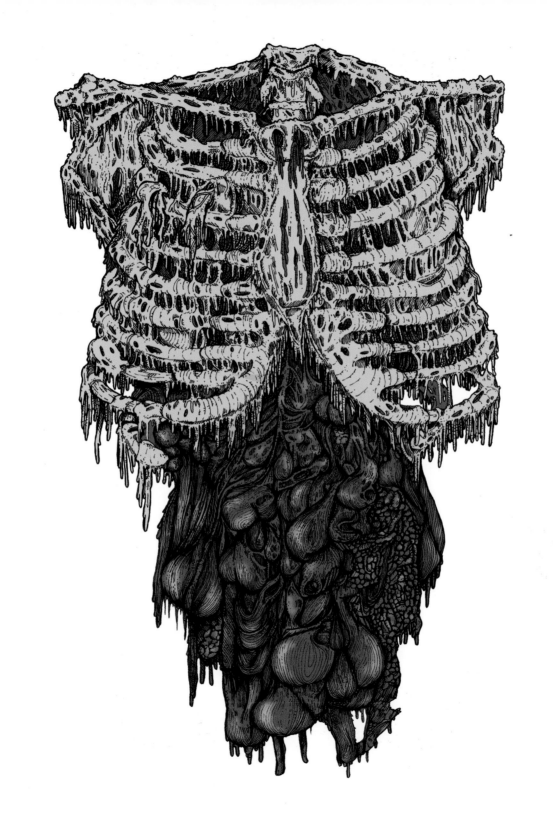

Guts, pen and ink.

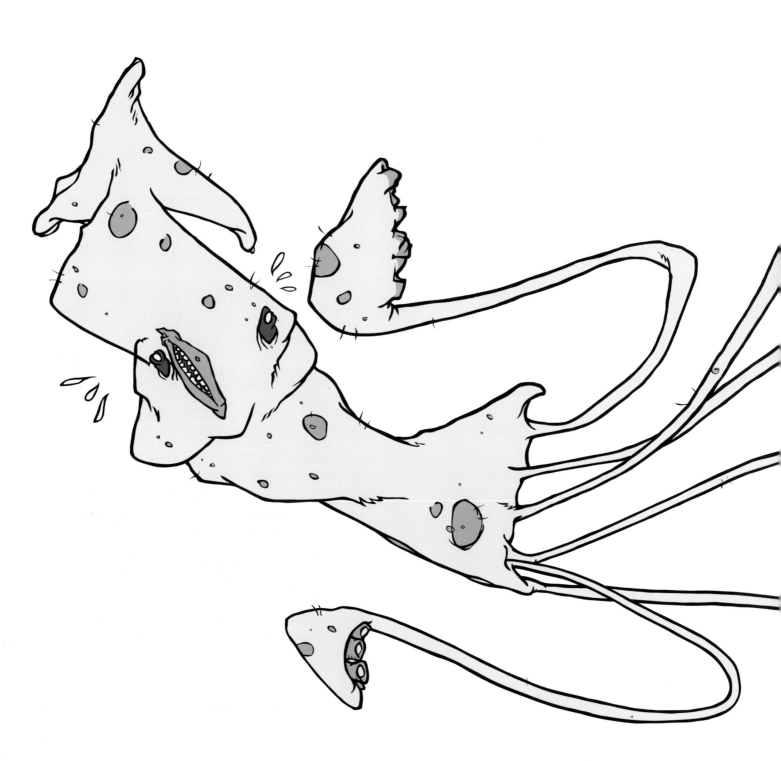

MR GAUKY

www.mrgauky.com
www.myspace.com/mrgauky

Mr Gauky was born in Yorkshire, UK. His artwork consists of painting, drawing, sculpting and digitizing a 'powerful gang of long-armed misfits and creatures' called Slouches, which are inspired by his everyday encounters. He discovered the Slouches on a childhood outing with his parents:

> At the naive age of four, I was taken on a day trip to the Yorkshire Dales by my parents. It's still unknown whether they got distracted by the lush surroundings and completely forgot about me, or whether their plan was to abandon me and leave me to fend for myself.

> I stumbled around the Dales aimlessly for what seemed like days, until I came across a tribe of very hairy creatures called Slouches. They took an instant shine to me and took me in as one of their own. They taught me the ways of the Dales and introduced me to art. I quickly developed these skills and spent most of my days painting their portraits.

> Many years passed and it wasn't until I was twenty-one that I decided to try and make it in the world of man and enrol at art school.

Skateboarding has been part of Mr Gauky's life for the past eight years and through skateboarding he has met lots of like-minded individuals. He has also recently produced a board graphic for the London-based Science Skateboards.

Mr Gauky had a much-acclaimed solo show of his portraits of the Slouches in Cambridge in early 2006, but he also enjoys collaborating with other artists on projects:

> There are so many rad artists out there, both internationally and locally. The web is a great resource for finding out about them and networking. Don't be scared to collaborate with these people; most of the time it pays off and it may lead to other fun.

Sea Monster Ain't Got No Mussels, Adobe Illustrator.

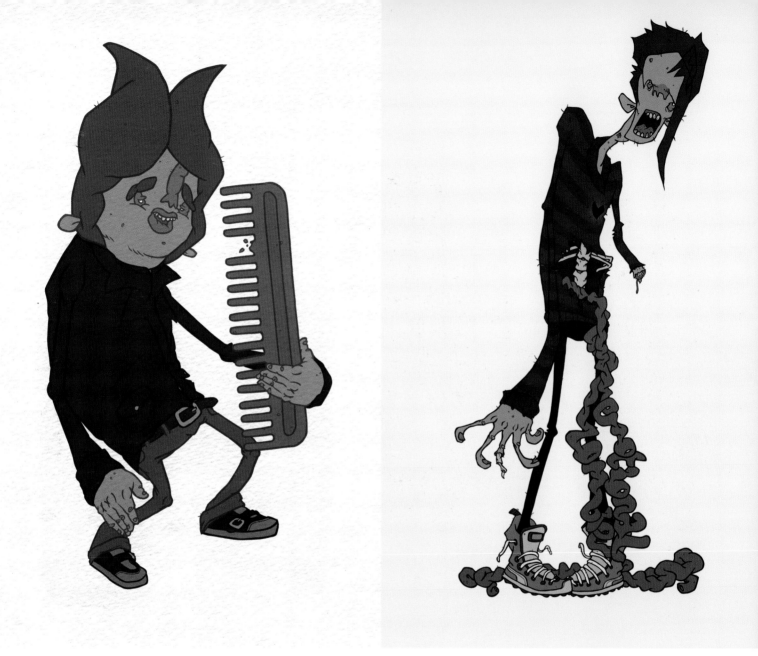

Left: *I'm Quiffy*, Adobe Illustrator.
Right: *Without You I Become An ...*, Adobe Illustrator.

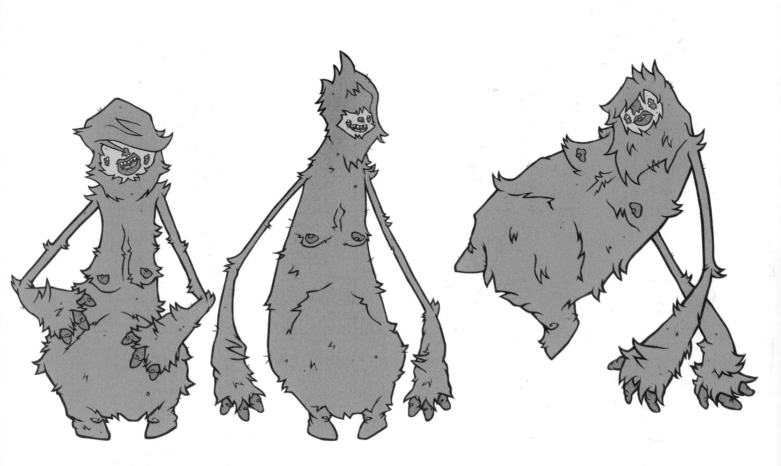

Slouches Gang, Adobe Illustrator.

Amber, pen on paper.

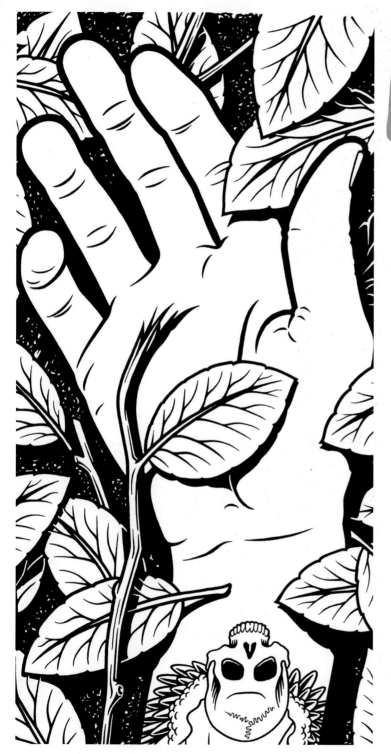

MIKE GIANT

www.mikegiant.com
www.rebel8.com

Mike Giant is from New Mexico and is a multi-talented artist, designer, graffiti artist and tattooist. He originally studied architecture after high school, but left the course to move to San Francisco and work full-time designing graphics for Think Skateboards. His time working for Think helped develop his impressive and distinctive style:

> The way I draw now is a direct result of my time doing skateboard graphics for Think. I learned how to draw things in a way that made it easy for them to be silk-screened on skateboards. Line weight was a big concern when the line was being used to 'trap' the screened colours underneath. I continue to draw the same way, even though printing technology has changed a lot over the years.

His work is highly precise, hand-drawn, black-and-white images, clearly reflecting his tattoo background but infused with other influences and interests such as Buddhism, graffiti, the Mexican Day of the Dead and skateboarding.

> Generally, I work in a very graphic black-and-white style. Imagery and themes change from piece to piece. Jim Phillips is my favourite artist within skateboarding. The work he did for Santa Cruz in the eighties rules. Outside of skateboarding, my favourite artist is Charles Burns. His black-and-white inking style is my foremost influence.

Mike has also spent brief periods living and working in London and New York, but now resides back in his home town of Albuquerque, where he continues to tattoo and undertake freelance projects. He also provides all the artwork for clothing company Rebel 8.

Hand, pen on paper.

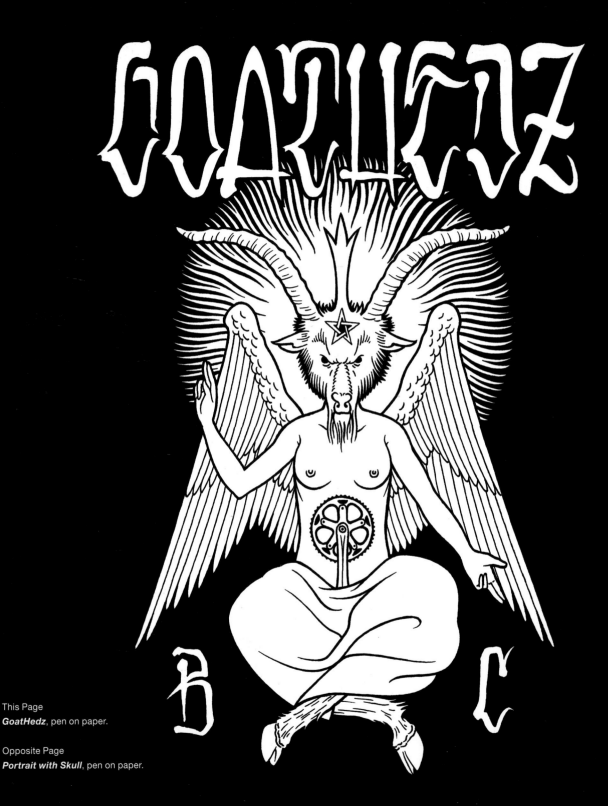

This Page
GoatHedz, pen on paper.

Opposite Page
Portrait with Skull, pen on paper.

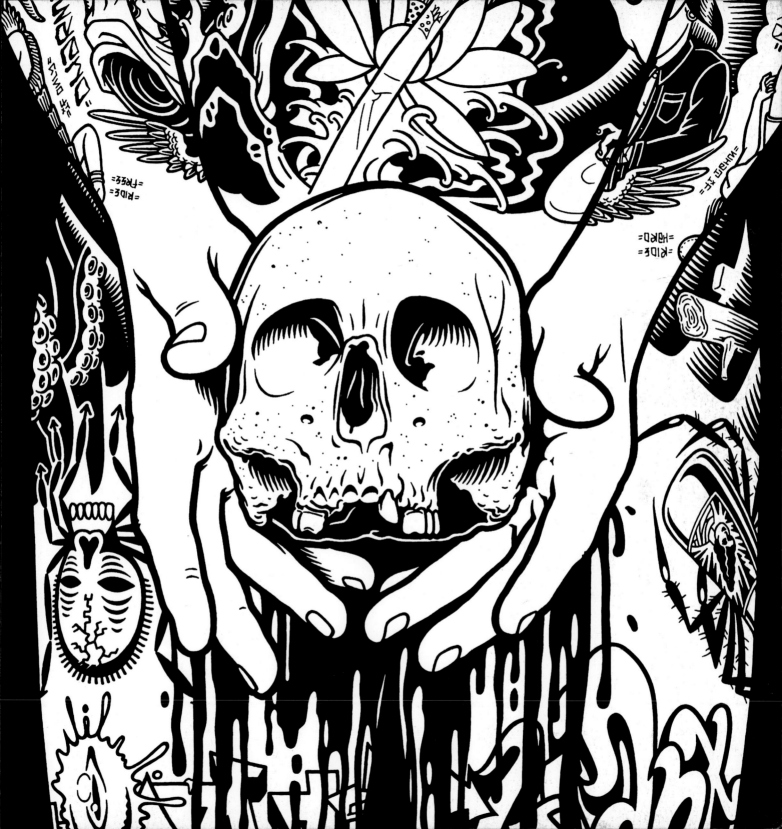

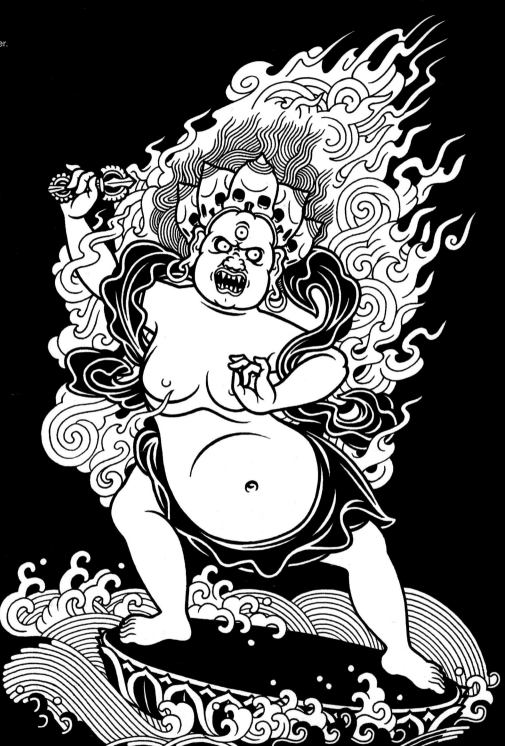

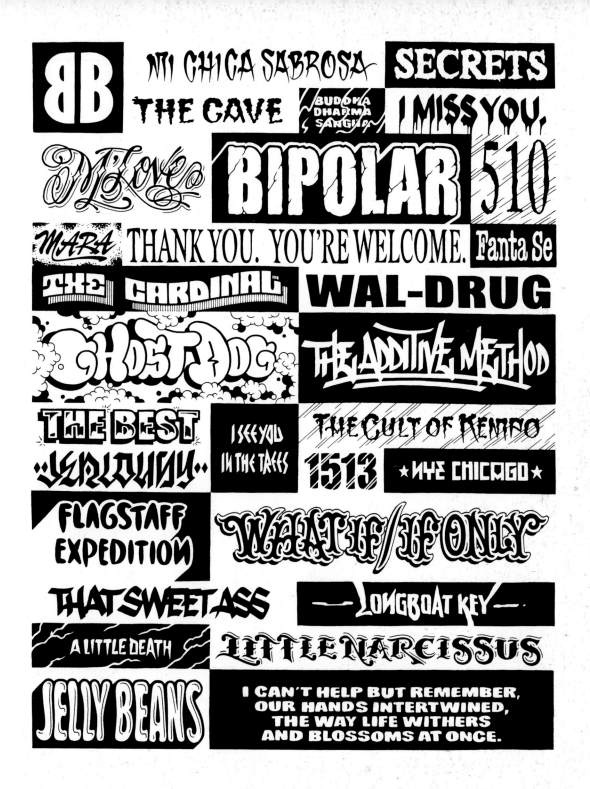

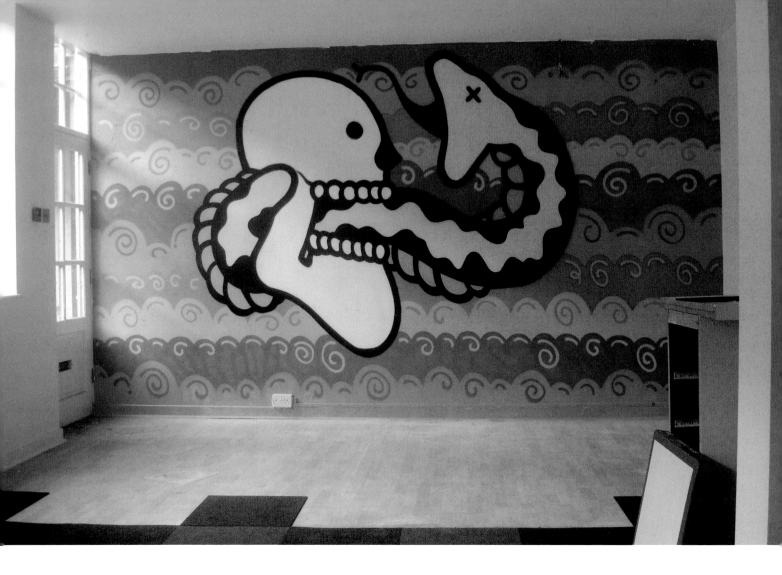

This Page
Skull and Snake, spray paint.

Opposite Page
Left: **Helga's Butterfly**, pen, ink, Adobe Photoshop.
Right: **The Autopsy**, pen, ink, Adobe Photoshop.

Following Spread
Left: **Earl Shilton**, pen, ink, Adobe Photoshop.
Right: **Untitled**, pen, ink, Adobe Photoshop.

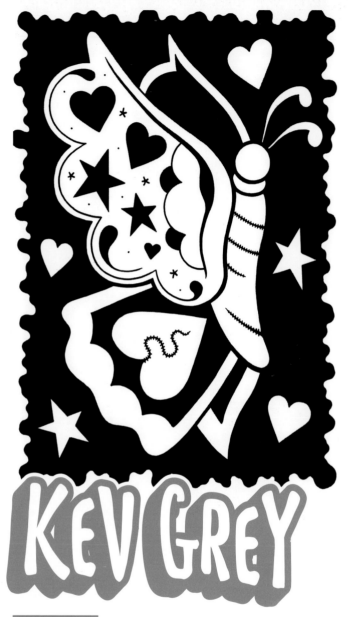

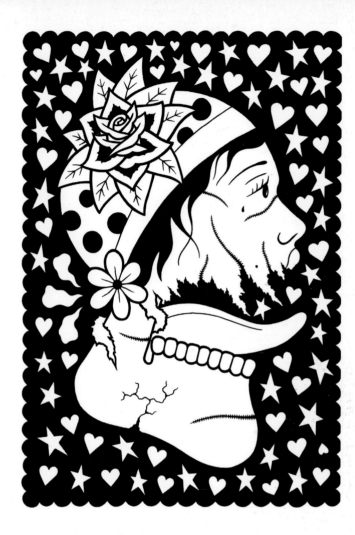

Kev Grey

Kev Grey is an artist and illustrator originally from Liverpool, but now based in Sheffield, UK.

His passion for tattoos is unmistakable in his work. Inspired at an early age by his grandfather's Navy pin-up tattoos, Kev has taken retro tattoo themed designs and created his own unique style by fusing them with another of his inspirations, his lifelong love of comics.

I'm influenced by black-and-white comic strips, tattoo flash, old rock 'n' roll music, getting tattooed and honky tonkin'. I like to try and draw pictures that have the same impact as a good piece of tattoo flash: simple, bold and beautiful.

Kev has produced two series of boards for Liverpool-based East Skateboards, and a graphic for France's Logo Skateboards. Other outlets for his work include T-shirts, record covers, tattoo designs and fanzines.

I produce most of my work using a black drawing pen with brush and ink, and occasionally use Photoshop if I want to add colour. I also work with spray paint when painting on walls.

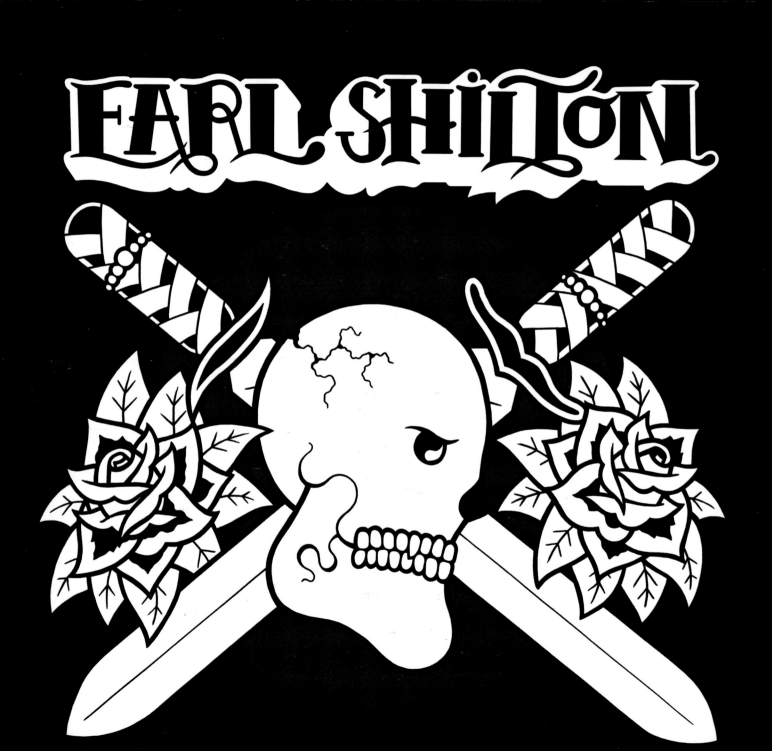

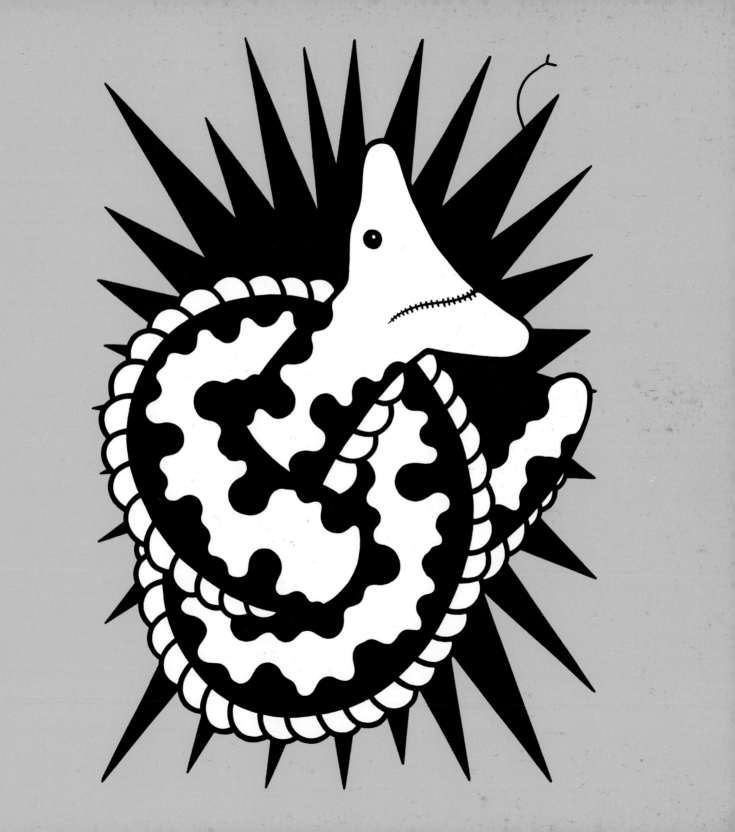

STEF GRINDLEY

www.selfctrl.net
www.outcrowdcollective.com
www.coptercentral.com

Stef Grindley is an artist and graphic designer based in Birmingham, UK. He started skateboarding in 1987 when he was ten years old.

It pretty much consumed my childhood and moulded me as a person. Through skateboarding I was introduced to punk rock music like Black Flag and Minutemen. In the nineties I started playing in bands and creating posters using pens, old magazines, a craft knife and a photocopier. I have no doubt that pretty much everything that I have done in my life so far has stemmed from me riding a skateboard.

After dabbling in film studies for a short time at university, and despite an initial hatred of computers, Stef found himself an intern position at a web design company, and discovered a love for Apple Macs. He soon co-founded his own company where he was able to focus on fun projects rather than blue chip clients. His design work has appeared in magazines, on websites, CD covers and T-shirts, and he has lent his skills to the design and layout of this book.

Stef describes himself as an artist working as a designer:

I have to make a clear separation between the two disciplines even though essentially they are both creative pursuits. Artistically I like to express the way I am feeling from day to day. I will often illustrate or typographically express abstract concepts, thoughts or phrases that float through my head. Stylistically I don't have a set style that I always stick to. I love drawing in vectors but there are so many different ways of creating, I don't like to just sit behind my computer!

Stef is a member of the Outcrowd Collective, a self-curating group of skateboarders, musicians and outsider artists, and has exhibited his work as part of their many group shows. He is also a musician and member of the band Copter.

This Page
Momoko at Supersonic,
vector illustration.

Opposite Page
Expressway to yr Skull,
vector illustration.

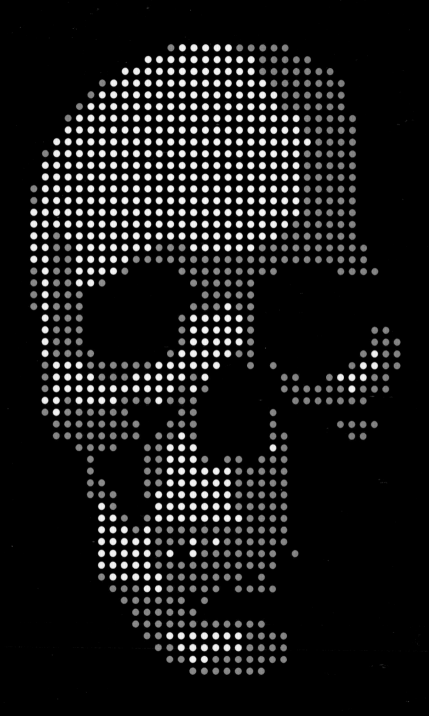

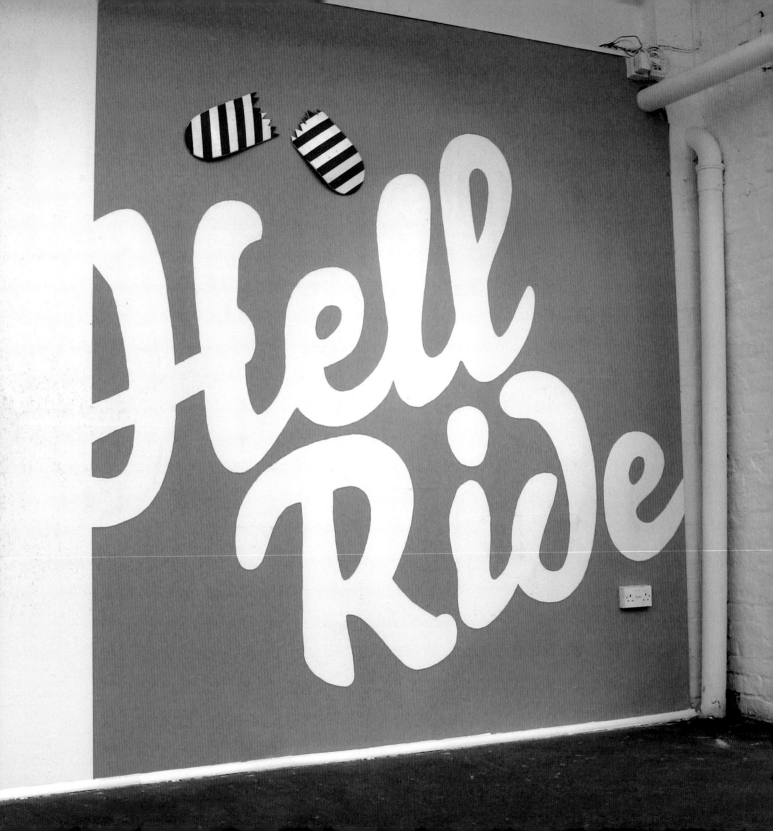

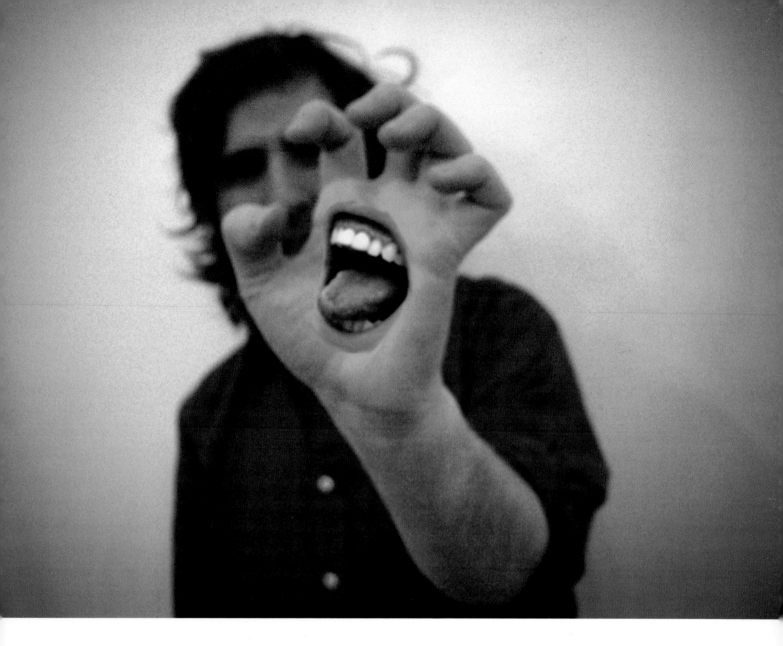

This Page
Tribute to Jim Phillips, manipulated digital image.

Opposite Page
Hell Ride, housepaint on gallery wall.

DAVID HALE

www.davidhale.org

David Hale grew up in a suburb of Atlanta, Georgia:

> There, self-expression is something that might bother the neighbours. I started drawing before I can remember, and have been addicted to it ever since. I still can remember the first painting I ever did, and how happy it made me. I have been embracing that feeling continually. I always used art as a much needed outlet for rebellious self-expression.

David's artwork primarily takes the form of large acrylic paintings, but he also likes to combine media: using markers and pens to make painting 'feel more like drawing'. He often paints entire pieces at live music events.

> I am entirely addicted to making art, I think about it all the time, it keeps me up at night, it is what I want from life.

David started skateboarding at a young age but didn't realize its potential until he got hooked on surfing, but as he lived in land-locked Atlanta, he took up skating more seriously:

> Skating offers so many palettes for people to present what they are thinking, feeling, or just who they are. You can learn so much about a person by watching them skate: I see it as a fluid, more physical and larger-scale version of painting. So over time my skating has grown to reflect my painting, and my painting now is influenced by my skating; both continually inspire the other. Now neither is an act of rebellion, but each is a way to interpret the world around me and the life I am living.

David graduated from the University of Georgia in December 2006 with a BFA. Following his graduation he moved to Cocoa Beach, Florida to take up a tattoo apprenticeship.

Figurescape, mixed media on canvas.

76

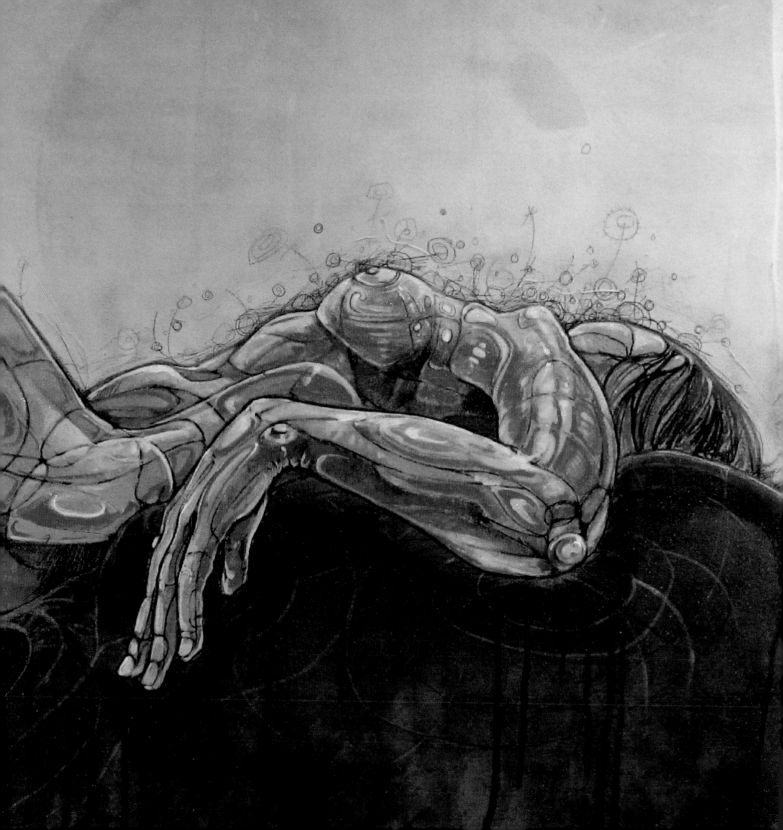

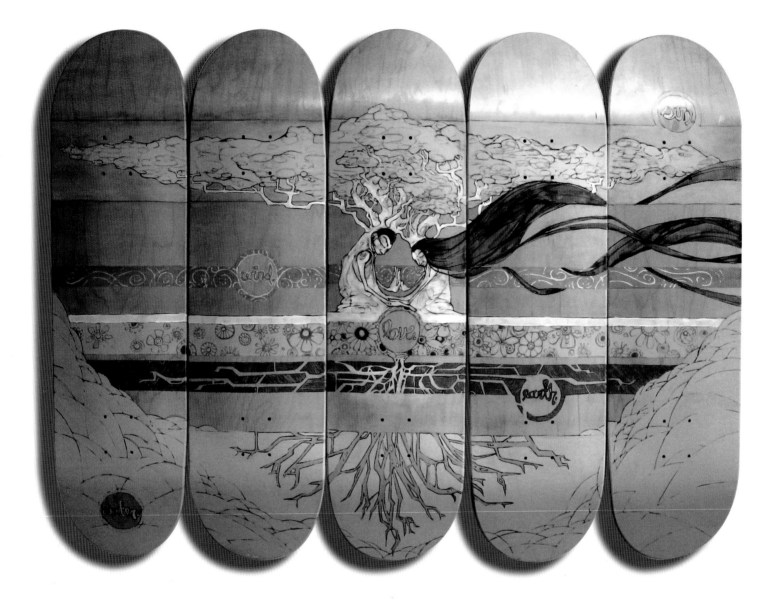

This Page
That Which Nurtures, acrylic, pen, ink and marker on skateboards.

Opposite Page
Left: **Patience is Growth**, mixed media on board.
Right: **Head Rush**, pen, ink and marker on skateboards.

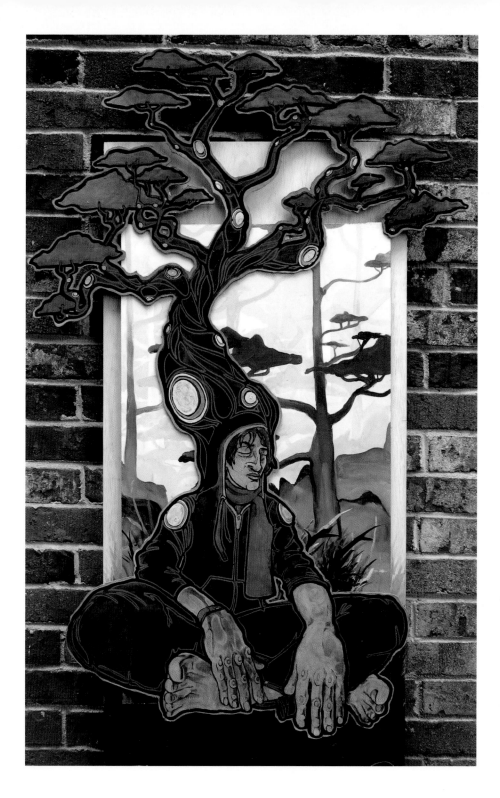
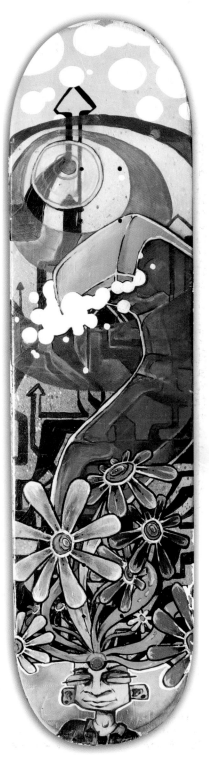

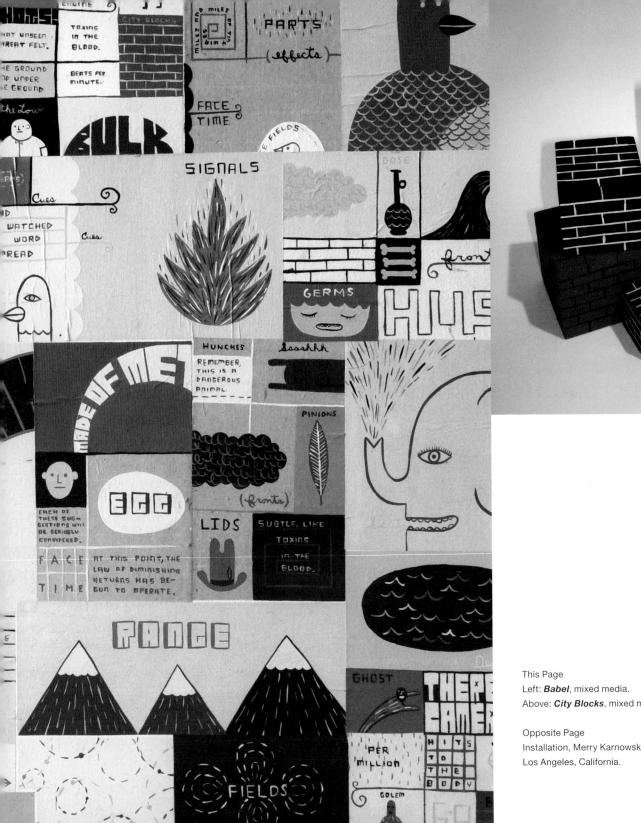

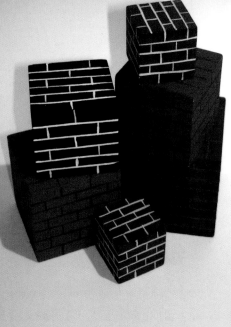

This Page
Left: *Babel*, mixed media.
Above: *City Blocks*, mixed media.

Opposite Page
Installation, Merry Karnowsky Gallery,
Los Angeles, California.

JIM HOUSER

Jim Houser is from Philadelphia, and is a completely self-taught artist who has been a drawer as long as he can remember. His work is a colourful mix of characters, objects and text. He predominantly uses acrylic paint on canvas and found objects. Objects on which he has painted include found wood and driftwood, shoes and basketballs. His canvases are often intricately painted, divided into lots of mini-paintings that make up one piece. His exhibitions take the form of elaborate installations made up of all the different elements of his work.

One of his inspirations is the outsider artist Howard Finster:

I can't go into it, it'd take hours of typing. Just read about his life. God commanded him to make 5000 paintings, and so he did. He actually made way more than that.

Jim has been skateboarding since 1984 when he got a skateboard for his eleventh birthday:

Falling down really hard is awesome. Learn to do things by yourself in a group. There is safety in numbers. Also, most people will not care how many stairs that was, or whether it was switch.

He has provided artwork and board graphics for several skate companies including Toy Machine and Designarium, and for other companies such as RVCA, Crownfarmer, Nike, Design Within Reach and Holeproof.

Jim has exhibited his work widely including regular shows at the Spector Gallery in Philadelphia, where prints of his work are available to buy. In 2005 he had a book of his work published called *Babel*.

Jim doesn't have a website but suggested:

Google all these things and people – they are radder and more interesting than me: Rebecca Westcott, Space 1026, Artjaw, Sweatheart, Adam Wallacavage, Isaac Lin, Richard Colman, Megawords, Smile and Nod, Ben Woodward, Traffic Skateboards, BARR, www.afbl.org, Lori D, Crownfarmer, Merry Karnowsky, Jonathan Levine, American Sneakers, Isiah Zagar.

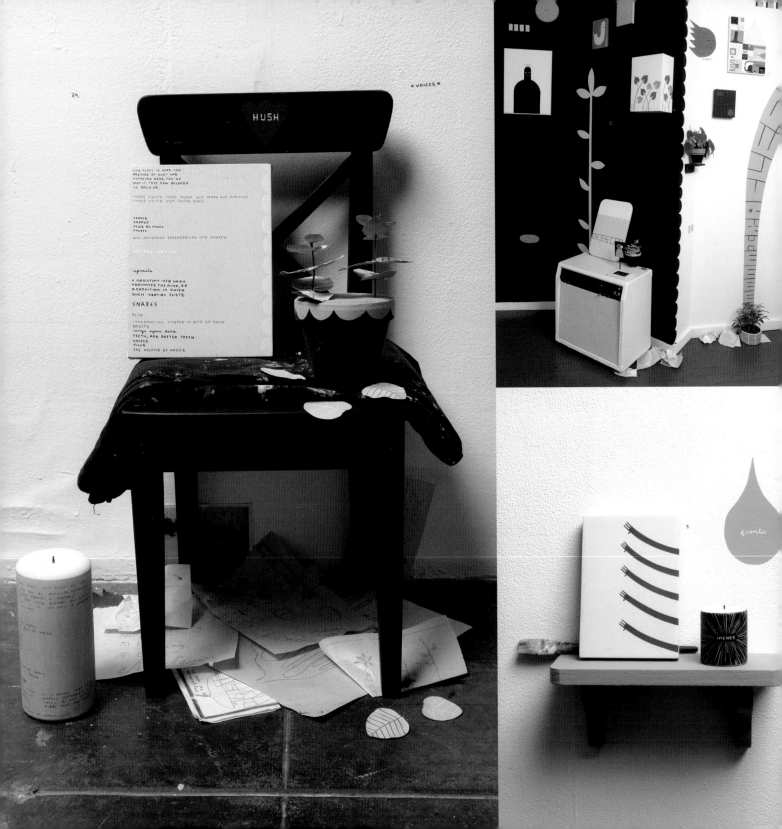

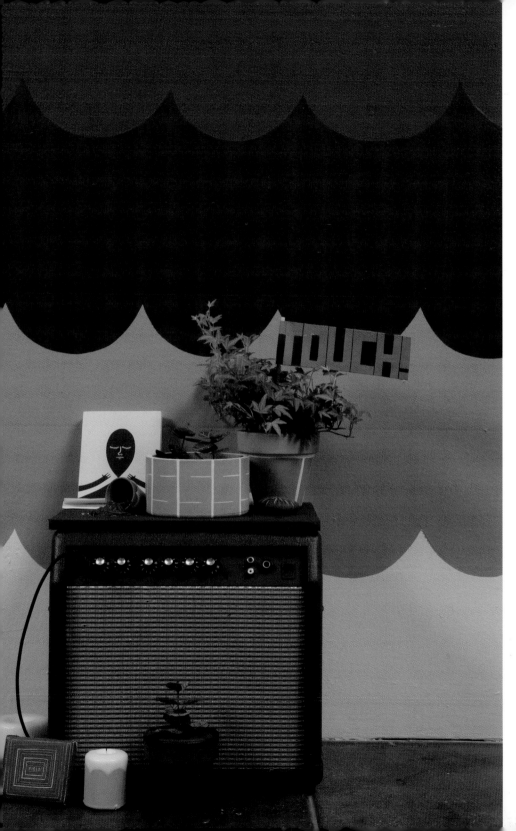

This Page
Amp, detail of installation, Merry Karnowsky Gallery, Los Angeles, California.

Opposite Page
Left: **Becky's Chair**, detail of installation, Merry Karnowsky Gallery.
Top right: Installation, Spector Gallery, Philadelphia, Pennsylvania.
Bottom right: **Shelf**, detail of installation, Merry Karnowsky Gallery.

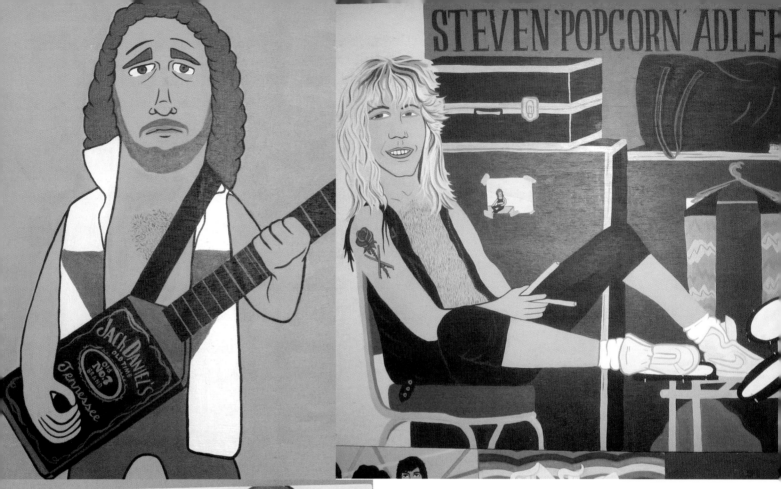

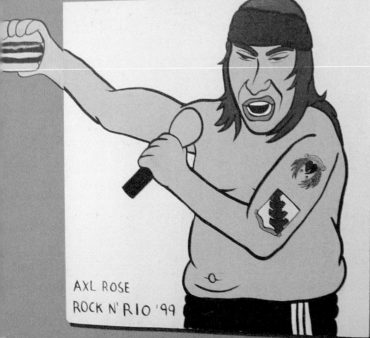

This Page
Top left: **Michael Anthony**, acrylic on wood panel.
Top right: **Steven Popcorn Adler**, acrylic on wood panel.
Bottom left: **Axl Rose Rock In Rio**, acrylic on wood.

Opposite Page
Blue Oyster Cult, acrylic on wood.

THOM LESSNER

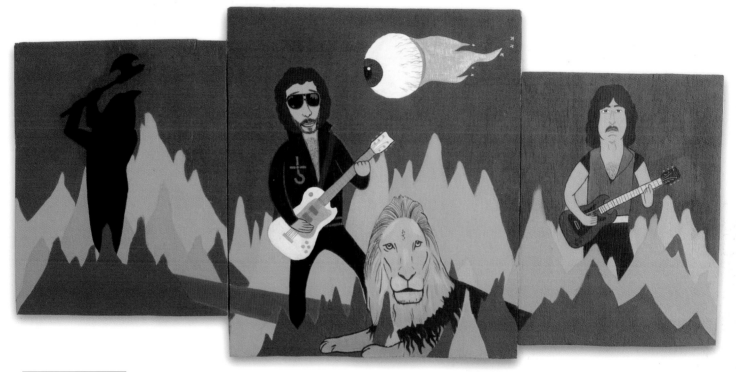

www.space1026.com
www.spectorspector.com
www.sweatheartsweat.com

Thom Lessner is a painter and printmaker originally from Ohio, but now based in Philadelphia. Thom is a member of, and works at, Space 1026, a gallery and studio space in Philadelphia.

Thom is known for his distinctive, original drawings and paintings of people and bands that inspire him:

> I draw and paint people I like to look at. It's simple and flat and fun.

In 2001, Paul, from the Paul Green School of Rock Music, convinced Thom to make his living by designing Rock School posters and pursuing other freelance art work. Since then he's produced work for companies including

Enjoi skateboards, Snickers, Autumn, Crownfarmer and Obey, plus his work has appeared in magazines such as *Vice*, *Thrasher*, *Swindle*, *Skateboarder* and *Heckler*, amongst others. He has also shown his personal work at a solo show at the Spector Gallery in Philadelphia.

Thom's life and art have been hugely influenced by skateboarding:

> I owe most everything I do to skateboarding. It has shown me how to be an individual and to learn to do whatever I wanted. It let me be creative.

His current major focus is his band, Sweatheart, whose debut album 'So Cherri' was released in 2006 on Tone Arm Records.

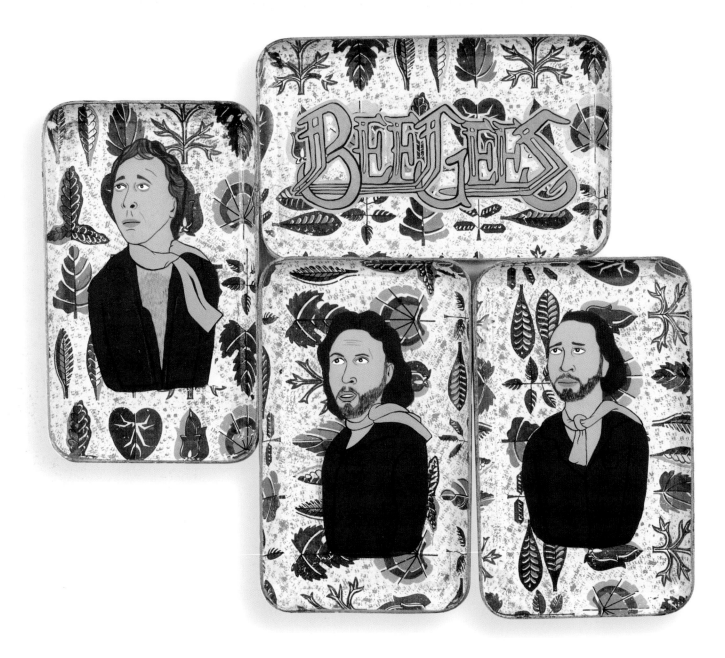

Bee Gees, acrylic on seventies bar coasters.

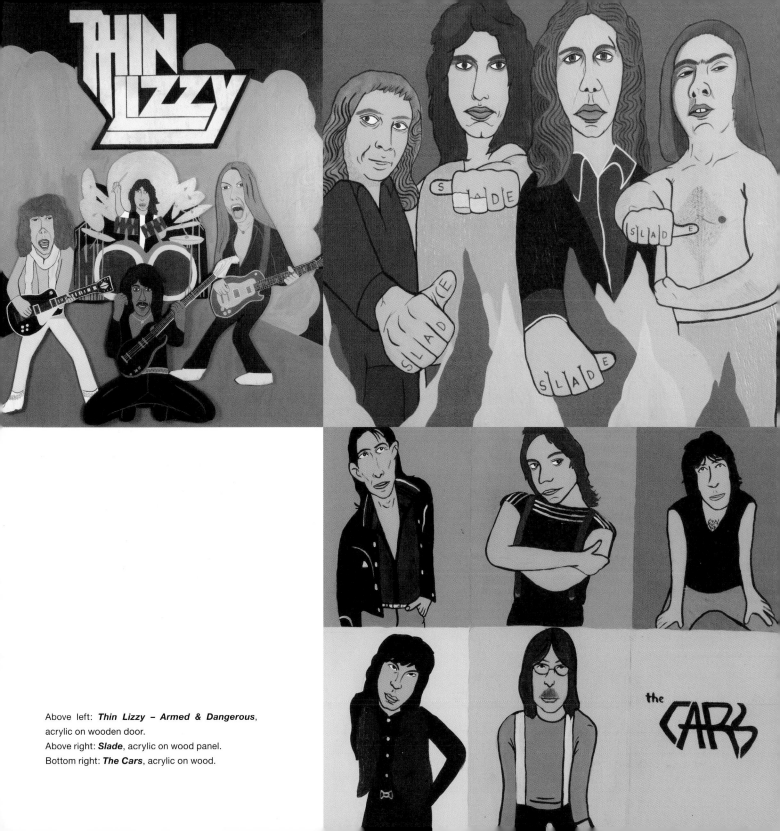

Above left: *Thin Lizzy – Armed & Dangerous*,
acrylic on wooden door.
Above right: *Slade*, acrylic on wood panel.
Bottom right: *The Cars*, acrylic on wood.

MAJLS

www.majls.org
www.orosmoment.com

Majls uses a variety of media to produce his work, including acrylic paint, screen printing, felt-tip pen, charcoal and spray paint.

I'm trying to work with as many different materials and platforms as possible … acrylics, screen printing, pens, the computer etc. Also producing limited edition clothes, single paintings and print series, for example. I'm getting into filming and motion graphics as well.

He has been skating since childhood, when going up and down a flat road in his home-town was enough to get him hooked.

I even used my skateboard on the very first canvases I made, rubbing my board against them, trying to give them a rough and authentic touch.

Majls describes his art as being about his life and his surroundings. Through his art he tries to understand and interpret his life and what he sees around him. Majls's logo and trademark is a bear costume.

I have dreams of achieving something bigger: thoughts, fantasies and imaginings. I'm pretty much trying to adapt what we call life, I guess. To get a grip of it … I'm just trying to fit in, but everywhere I go people are beating me up. Maybe it's because I look different …

Majls is from Sweden and he is part of the collective that runs the ORO Gallery space alongside fellow Swedish artist Ekta.

Majls and Ekta in clothes taken from the Man, City, Monkey series.

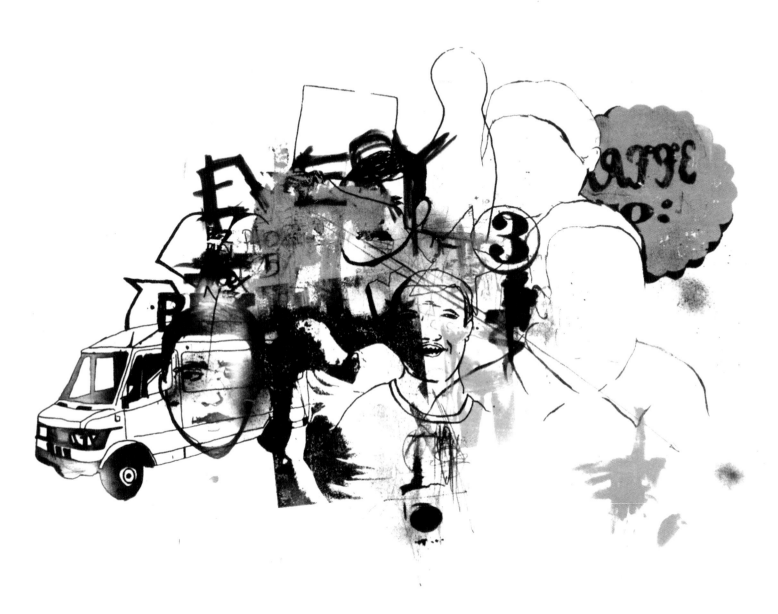

Every, acrylic, felt-tip pen, charcoal, spray and screenprint on canvas.

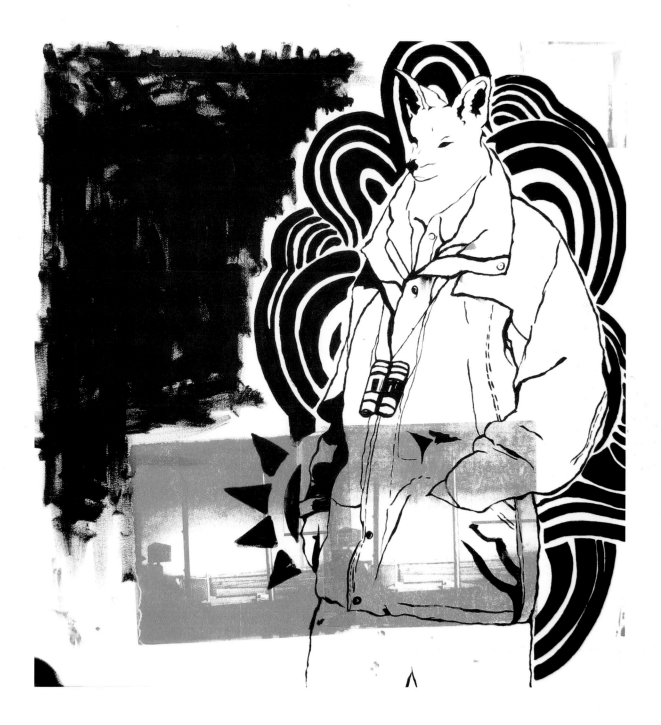

Seek, acrylic and screenprint on canvas.

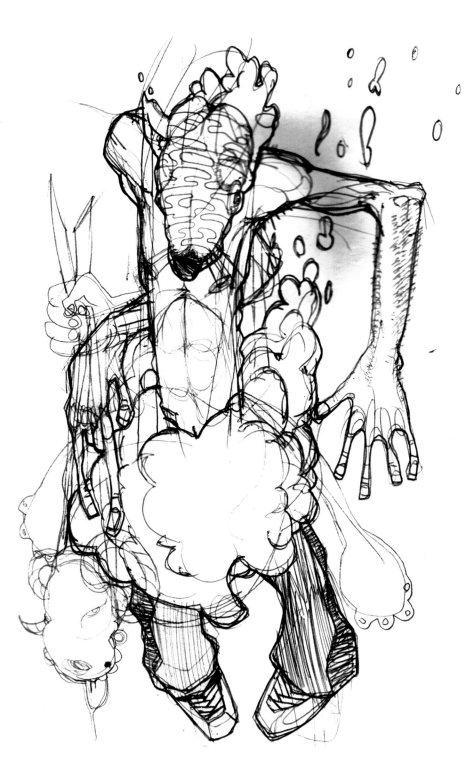

This Page
Rat Clouded, ballpoint pen and pencil.

Opposite Page
Computer Arts, pen and Adobe Illustrator.

FINN NEARY

www.yakahead.com

Based in Bristol, UK, Finn Neary, AKA Yaka, creates character-driven paintings, drawings and digital images.

He has been a freelance illustrator for the past five years, producing work for clients including *The Guardian* newspaper, the magazines *Mojo*, *The Big Issue* and *Computer Arts*, and Minute Skateboards and C1rca Shoes.

His influences range from comic art and artists such as 2000 AD, Calvin and Hobbes, Jamie Hewlett and Simon Bisley, to more traditional artists such as Egon Schiele and Modigliani.

Finn has been skating since around 1985, when he dropped in on a home-made four-foot mini-ramp his brother had created:

Since then it has had a part in my heart and mind. Skating has taken me all over, from Ipswich to Harrow, to Romford, Brighton, Ireland, Sweden, Africa, Bristol, France and Germany. Skating, therefore, has been a massive part of my development as a person, not just an artist. I've seen things, done things, created things, felt things, consumed things, absorbed things and challenged things that I never would have without being a skater.

Finn also produces canvases, limited-edition prints and T-shirts, and has exhibited his work across the UK, including in an exhibition at the V&A in London.

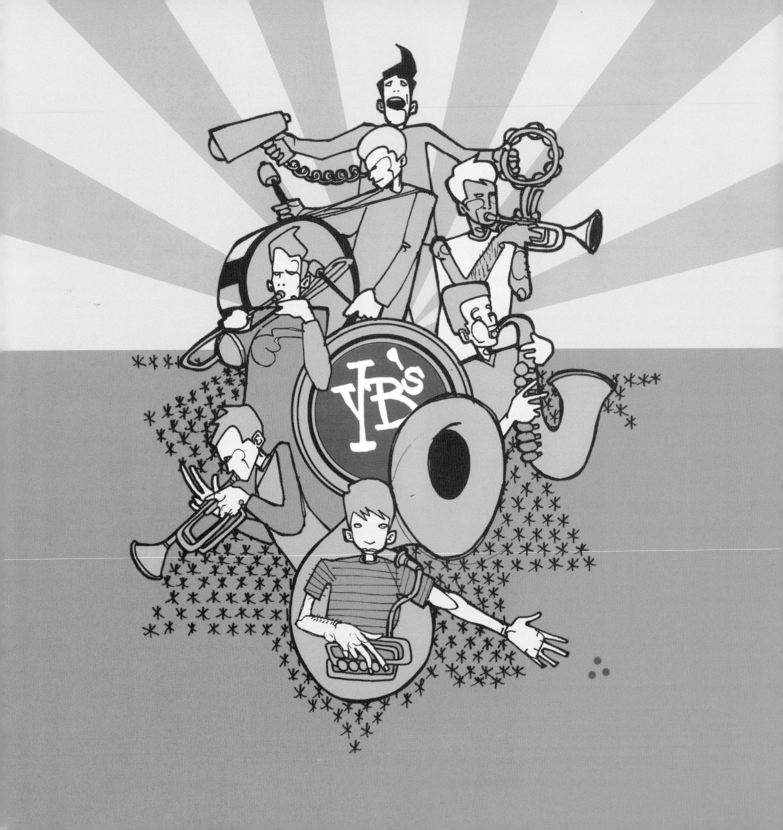

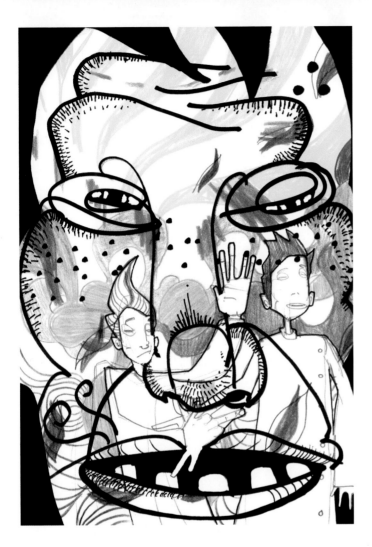

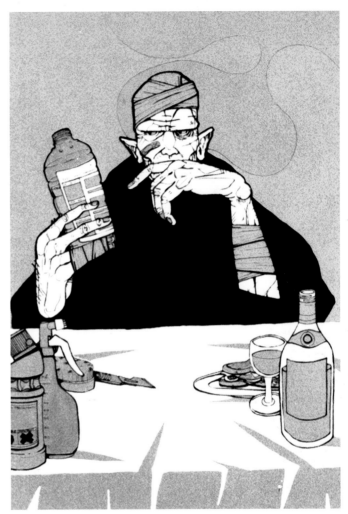

This Page
Left: *Yakaheadcolour*, colour pencil and felt-tip pen.
Right: *Saxtead Luncheon*, pen, ink, bleach and Tipp-ex.

Opposite Page
Young Blood Brass Band, pen and Adobe Illustrator.

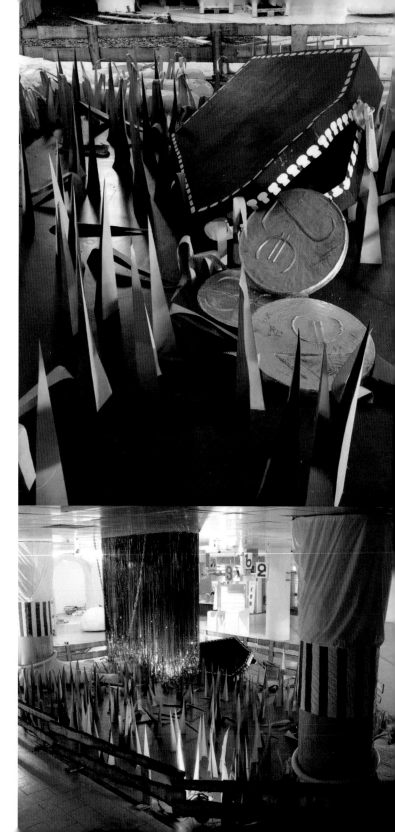

www.myspace.com/nomad_yesmad

Nomad is from Berlin and has been skateboarding and pursuing his street-based art for the past 20 years, since he was sixteen.

> Why skateboarding, punk rock, graffiti and hip hop, and not tennis or choir music? Probably because I didn't trust Boris Becker, Steffi Graf or the Pope. I trusted Natas and The Gonz, Dondi and Basquiat.... I chose something that I could adapt, that was affordable, something that challenged me and hurt me if I messed up.

Nomad's art takes many forms, including graffiti, installation, rag puppets, painting and sketches. He often collaborates with other artists and his work is frequently larger than life, covering top to bottom, ceilings and walls.

Nomad's no frills art is a reflection of his no frills lifestyle. He has often had to make do with what free or spare materials he could get his hands on in order to make his art. This was the case at the POET vs NOMAD Expo at the Partyarty Gallery in Berlin (2006):

> A gallery bombing: no budget, Berlin style. 'Hey, wanna come over and do an exhibition? We have no money to buy paint for you, but you can have free beers at the opening party.' Some leftover paint, a roller and three hours later we were done.

His love of skateboarding and art has provided him the means to travel the world. To Nomad, skateboarding and graffiti are the ultimate freedom of expression.

> Skateboarding and writing reflect the dynamic of life itself. This is freedom, and it's there to be taken.

This page and opposite page, bottom left:
Dongo, installation by Nomad and MissRiel, Ding Dong Art Show, Hamburg.
Opposite page, top left:
Reggie the Skull Rabbit, acrylic on stone steps, Yoyogi Park, Tokyo.
Opposite page, top right: Sticker, Berlin.
Opposite page, bottom right: *Untitled Trash Paintings*, Berlin.

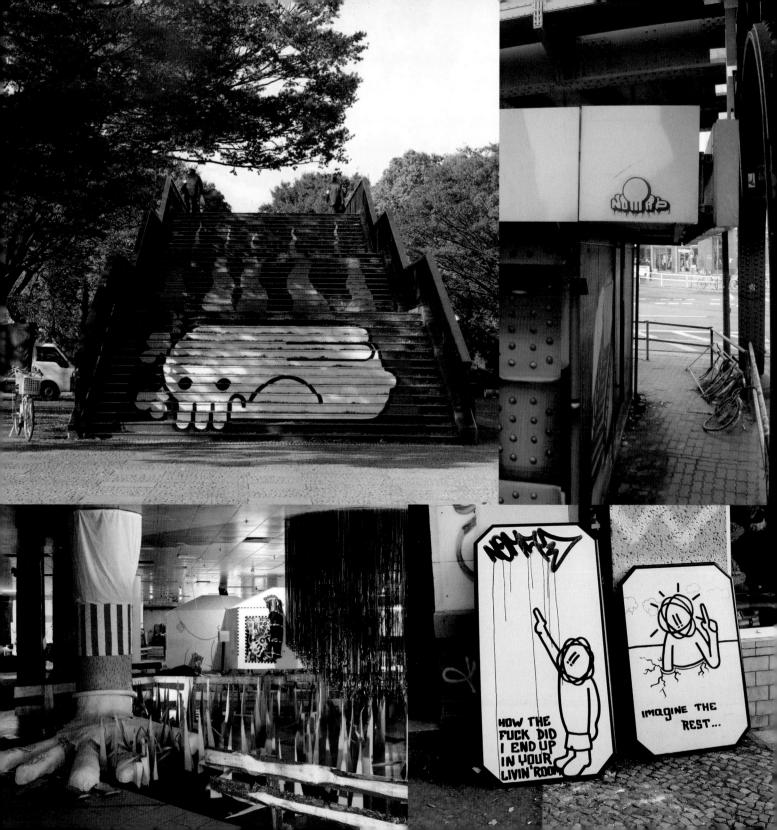

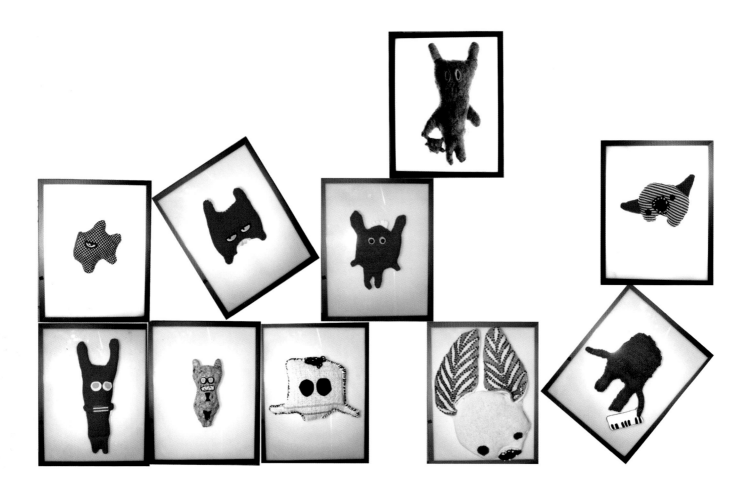

Eimertoys, hand-sewn puppets by Nomad and MissRiel.

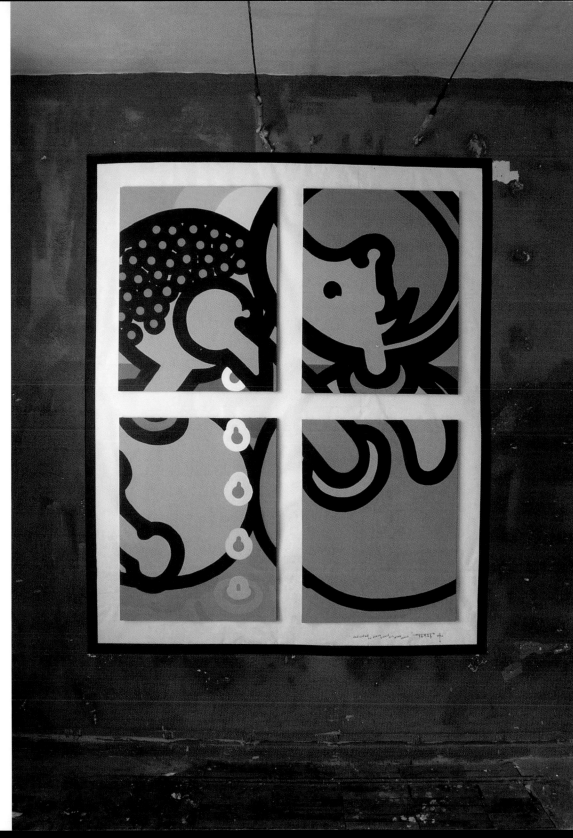

Untitled, acrylic on canvas.

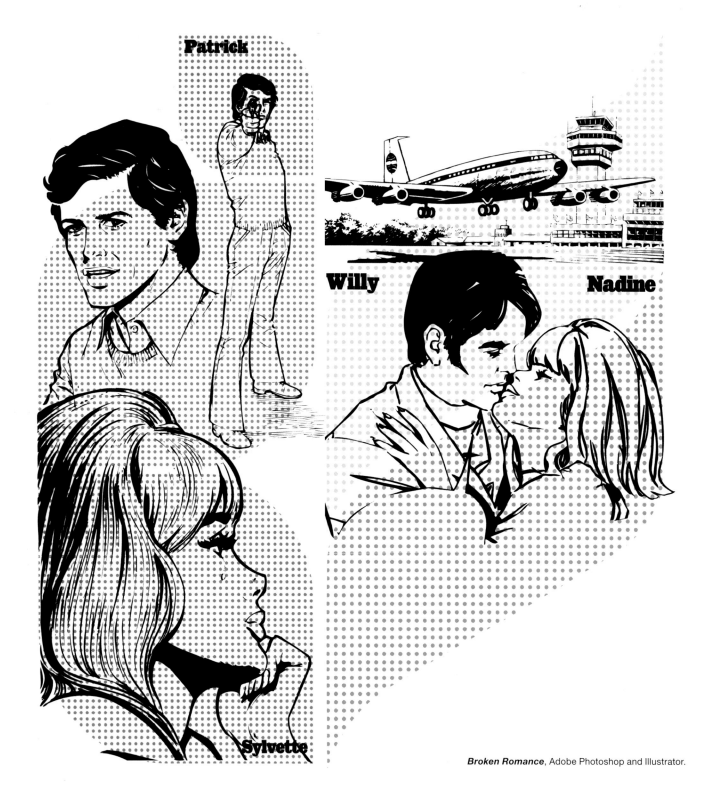

Broken Romance, Adobe Photoshop and Illustrator.

THE PHONO ART ENSEMBLE

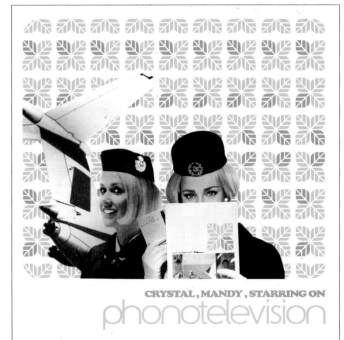

www.phono.com

The Phono Art Ensemble comprises French designers Thomas Le Mouellic (AKA Toma) and Antoine Caillet (AKA Ceerking). They are based in Clermont-Ferrand and Marseille respectively. After graduating from Bordeaux Business School, they each followed their own path into business life, working freelance or within internet companies:

> Since then, Phono has always been our graphic playground. The place we can achieve all kind of graphic projects, without suffering from the commercial pressure and client relationships we face in our everyday jobs.

They regularly produce graphics for France's Nine Yards Skateboards and record companies, as well as producing personal design projects and street-based art.

Thomas and Antoine are influenced by artists within skateboarding such as Don Pendleton and Evan Hecox, as well as graphic designers including Steven Harrington, Reid Miles and Rinzen, and the typography of Buro Destruct, Jason Walcott and Cornell Windlin.

> Our guidelines are quite easy to understand: we work for fun, and we like it when people smile when looking at our work. We focus on impact and the creative aspect of the message. There are so many ways to produce aesthetic layouts with modern tools that people forget what their works mean.

Top: **We Play, You Pay**, paste-up, France.
Bottom: **Phono Television**, Adobe Photoshop and Illustrator.

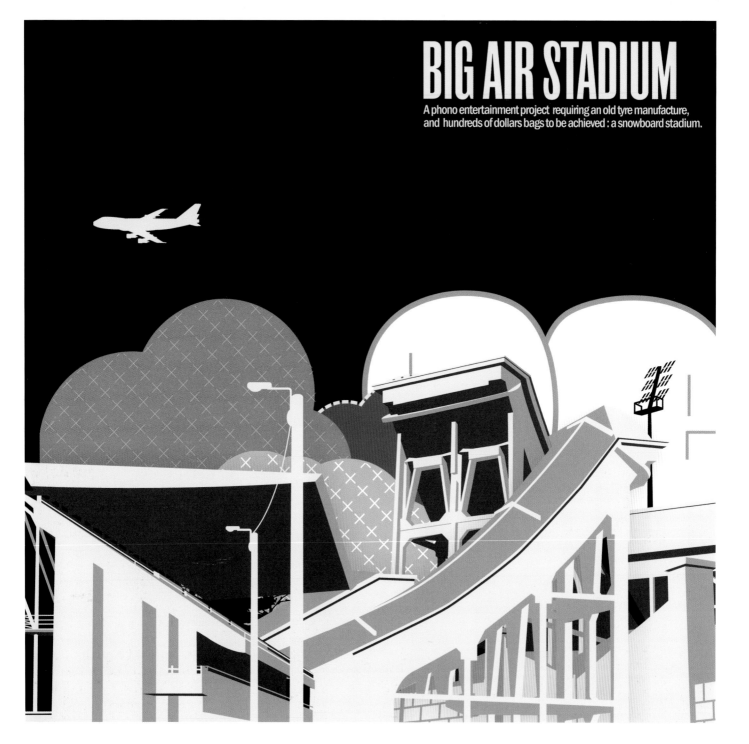

BIG AIR STADIUM

A phono entertainment project requiring an old tyre manufacture, and hundreds of dollars bags to be achieved : a snowboard stadium.

Big Air Stadium, Adobe Photoshop and Illustrator.

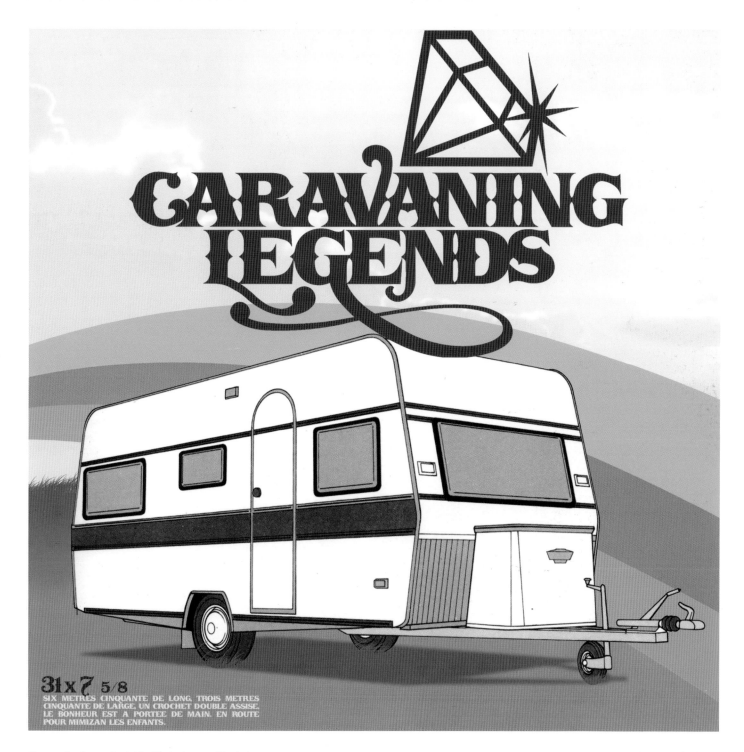

Caravaning Legends, Adobe Photoshop and Illustrator.

YOGI PROCTOR

Yogi Proctor is originally from the UK but has been living in the US for the last ten years, and is currently dividing his time between Chicago and San Diego.

During this period he has created the identities for many well-known skate companies, including Emerica, Etnies, Es and Popwar, and contributed artwork to RVCA clothing and Fuel/Fox TV.

Yogi had not studied art formally until recently, when he was accepted as the Presidential Merit Scholar into The School of The Art Institute of Chicago.

> I have been making art my whole life, but it is only in the last couple of years that I have really devoted myself full-time to making serious work. Before that, I think I was exploring all the possibilities of art making and idea development, through drawing, photography, painting, film,

design and so forth. This exploration of ideas and forms was primarily my inspiration. It resulted in my formal influences being found directly in front of me, very much the way as a skateboarder I would approach the environment with a creative intent.

Yogi's interest in ideas and forms can be seen in the piece he submitted to this book, an antique wooden chair sanded down to dust.

Yogi has been skating for the past 15 years, and can now see how his creative leanings were nurtured by his love of skating:

> I think in the grand scheme of things, skateboarding itself has been my education in terms of taking a creative approach to life, which is obviously something I did not realize at the time, but can now see in hindsight. Skateboarding puts you in a position of total creative engagement with the world around you. Skateboarding is a way of seeing.

This and Following Spread
Chair, documented performance of antique wooden chair sanded down to dust.

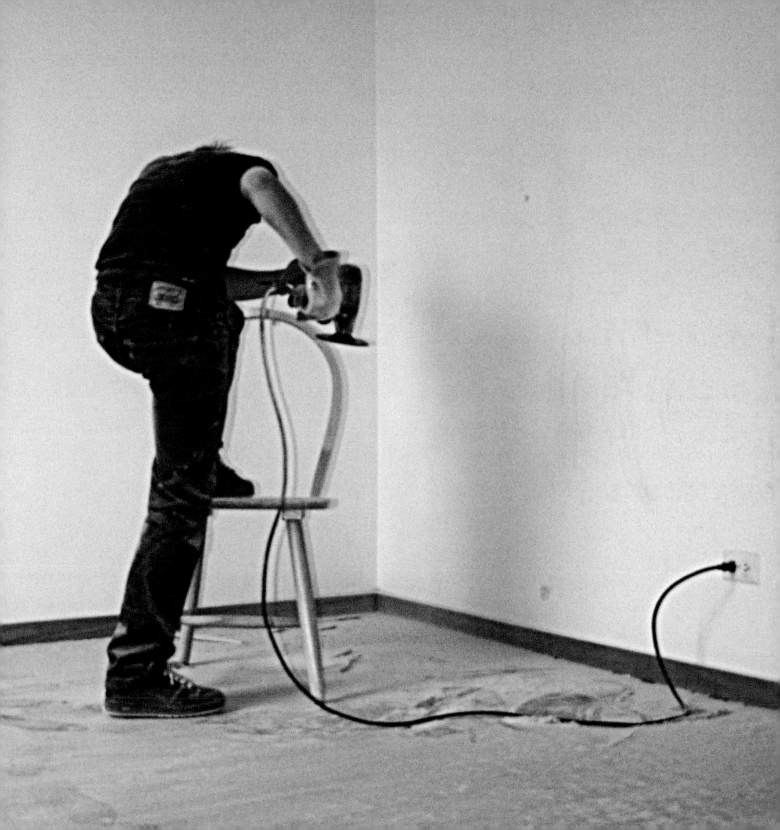

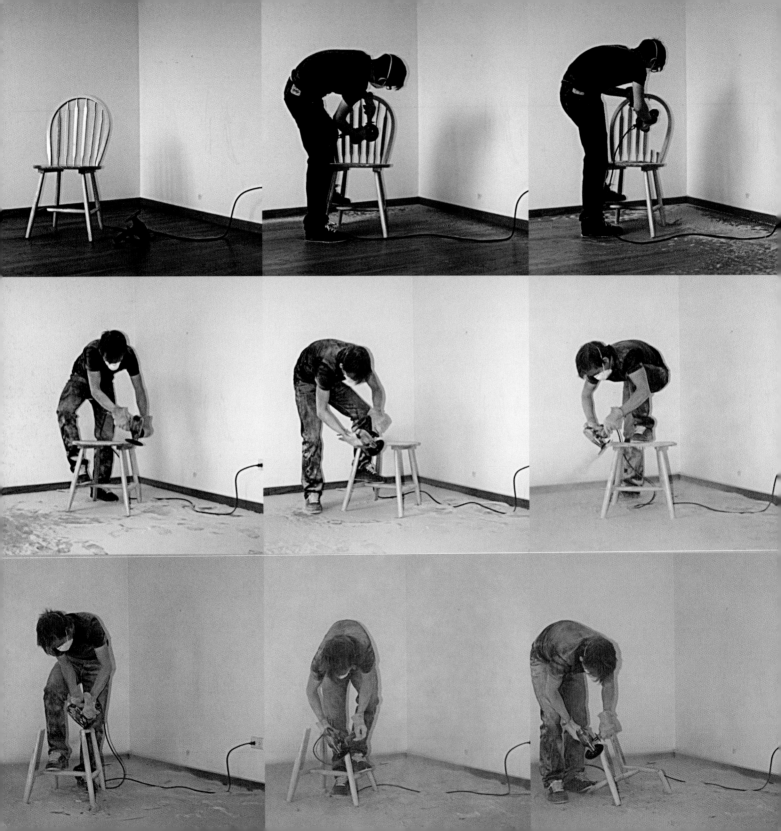

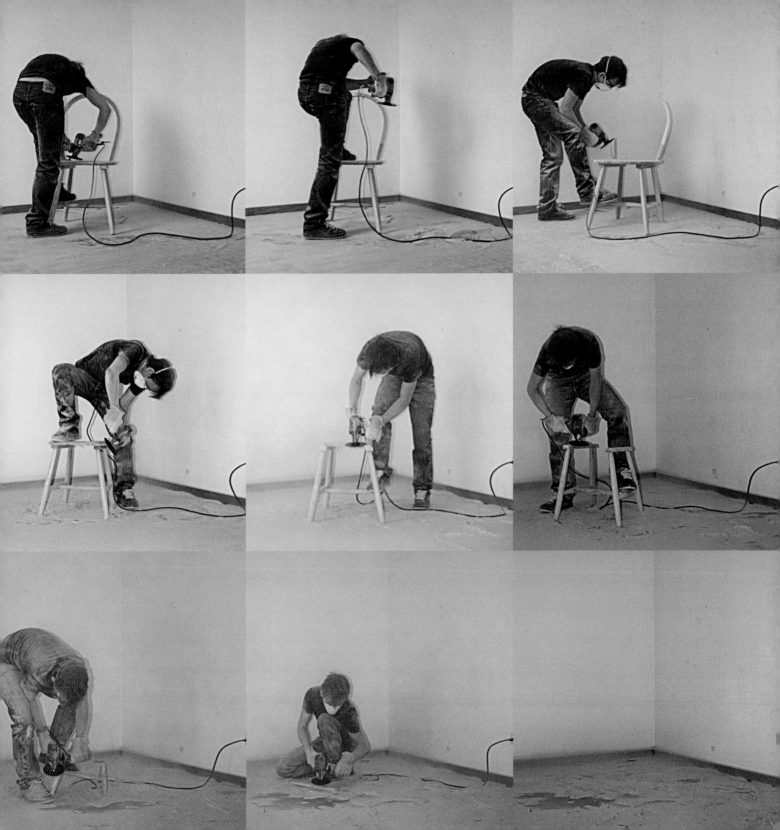

PRODUCT.TWO & ERIC PENTLE

www.fotolog.net/product_two
www.myspace.com/eric_pentle

product.two is an artist based in London. He started skateboarding as a child, although he gave it up for a number of years after 'breaking his face' learning to Ollie. He sees skating as a child and skating as an adult as two different experiences:

> As a child your skateboard was something you played with for a while and then forgot about. It only affects very short periods of time. As an adult the skateboard changes your day, week, year, career, relationship, health, art and so much more. Sometimes you hate it; sometimes you love it, but you don't ever stop.

Most recently, product.two's work has been based around collaborations with the mysterious eighty-four-year-old conceptual artist and intellect Eric Pentle. Together they have created numerous street installations, sculptural and conceptual pieces. One of their installations, a collaboration with artist Dave the Chimp, is a realistic, life-sized model of a man that is placed lying in the street, and the reactions of passers-by are documented on film. product.two and Pentle also use a variety of found objects that are then signed by Pentle in the manner of Duchamp, and left in the street surrounded by a chalk square.

Other works include several mixed-media 3D miniature scenes that depict gallery-goers contemplating a piece of Eric's work. The scenes are hung vertically in the street.

> As a skateboarder, you become far more active in a city. You discover areas and objects that for other people would be indistinguishable from the blank grey mess that they see. Architecture becomes a playground and this new freedom opens opportunities for your art.

Detail of street installation, mixed media.

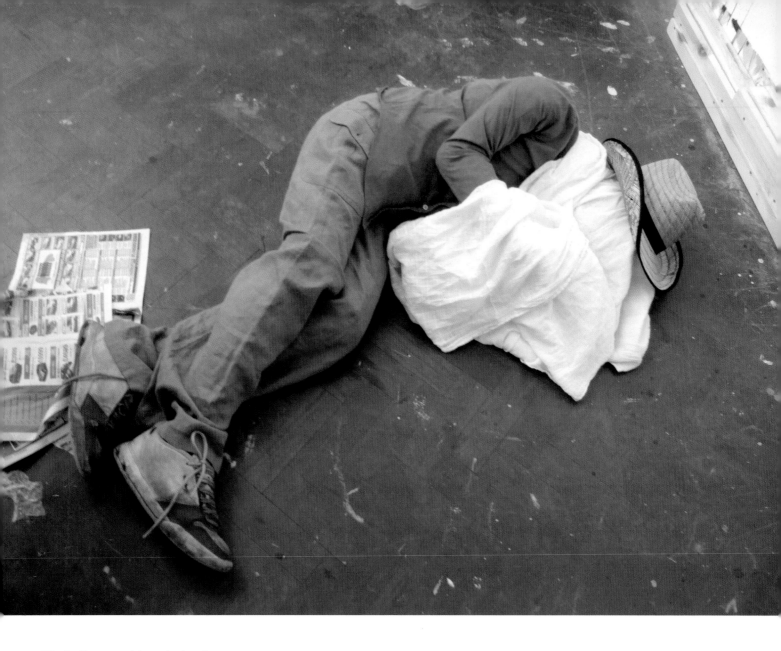

Life-sized human sculpture, mixed media.

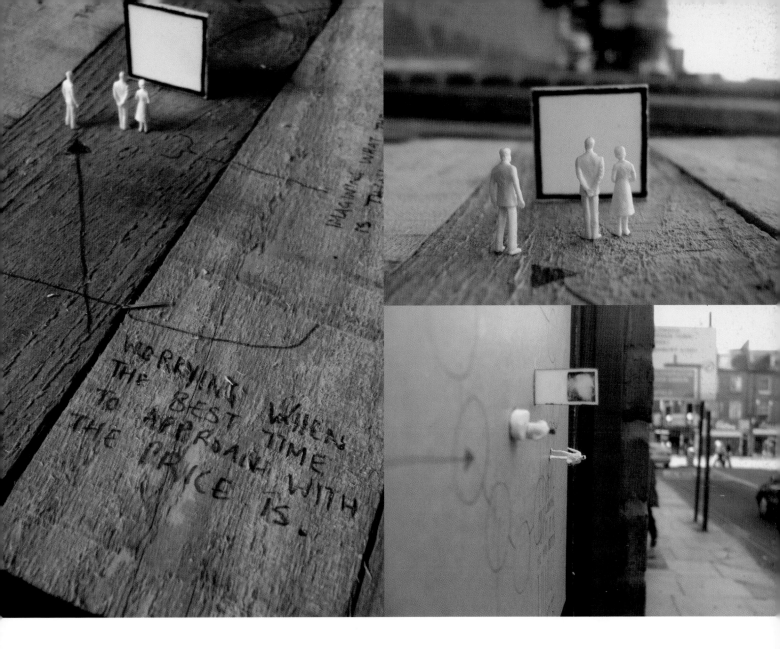

Details of street installation, mixed media.

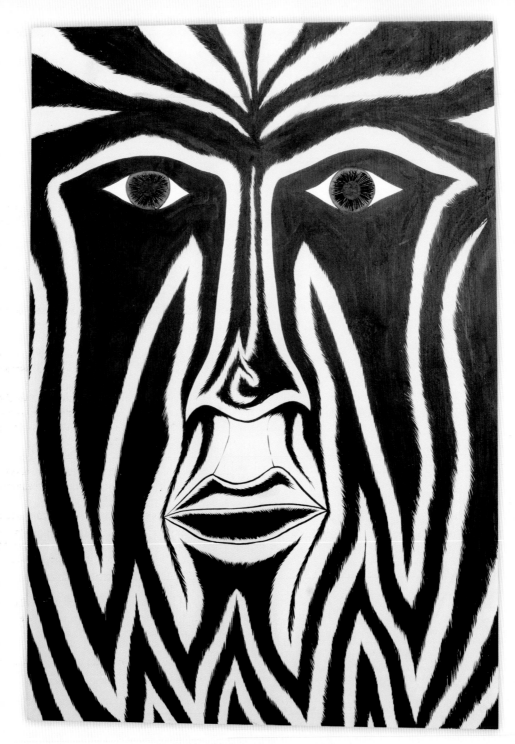

Untitled, acrylic and indian ink on MDF.

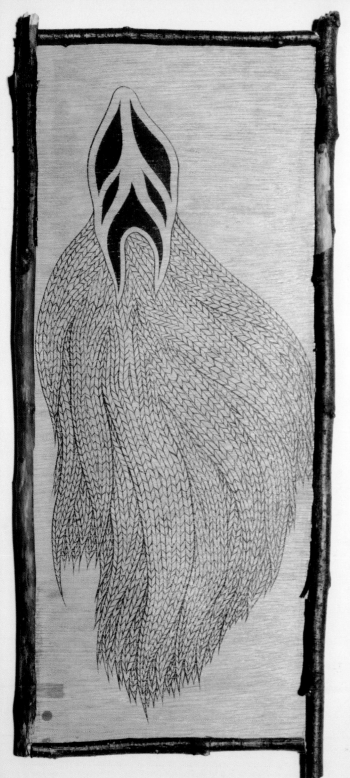

TOBY SHUALL

www.suburbanbliss.co.uk
www.movingunits.co.uk

Toby Shuall is a former pro-skater from London. He was born and raised in suburban London and grew up skating the streets of the city.

Toby spent part of his professional skateboarding career in California, skating in Santa Cruz. On his return to the UK in 2000 he launched his own T-shirt company, Suburban Bliss.

As well as giving him the opportunity to travel, skateboarding has influenced his life and art in a more general way:

> It showed me a different perspective on my environment. It made me look at things differently, which inspired me to make art.

Toby is one of the founding members of the Side Effects of Urethane, a collective of skateboarders who put on group shows of their work and create skate-related installations. He has been involved in their shows, exhibiting his work around the UK and abroad.

Unable to skate in the past few years due to a skate-induced ankle injury, Toby now focuses on his company and his designs and ambitions for it.

The recurring themes in his work are the combinations of his figurative/facial designs that interchange with abstract patterns. He uses materials such as acrylic paint, indian ink and pen on paper and wood. There are also elements of nature and the natural world in his designs and art, and sometimes in his choice of materials.

Artists that have inspired him over the years include Paul Noble, Robert Crumb and Barry McGee, to name a few. Toby doesn't like to intellectualize about his own work:

> I only draw stuff from my mind. I don't think about it too much, it just comes out.

Spirit, indian ink on ply wood.

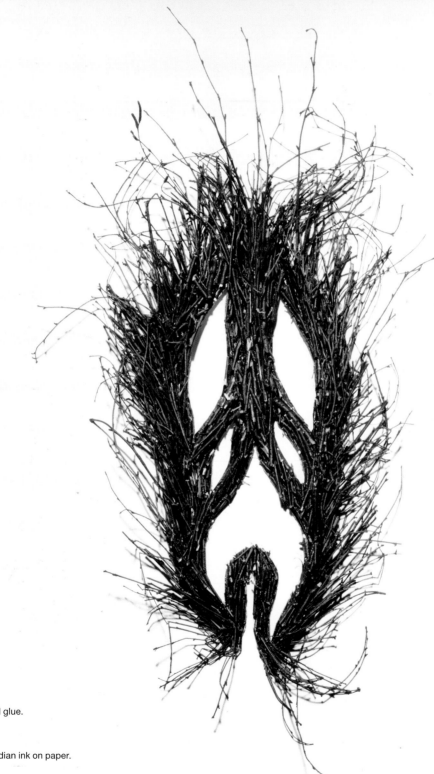

This Page
Forest Face, twigs and glue.

Opposite Page
Flowers and Faces, indian ink on paper.

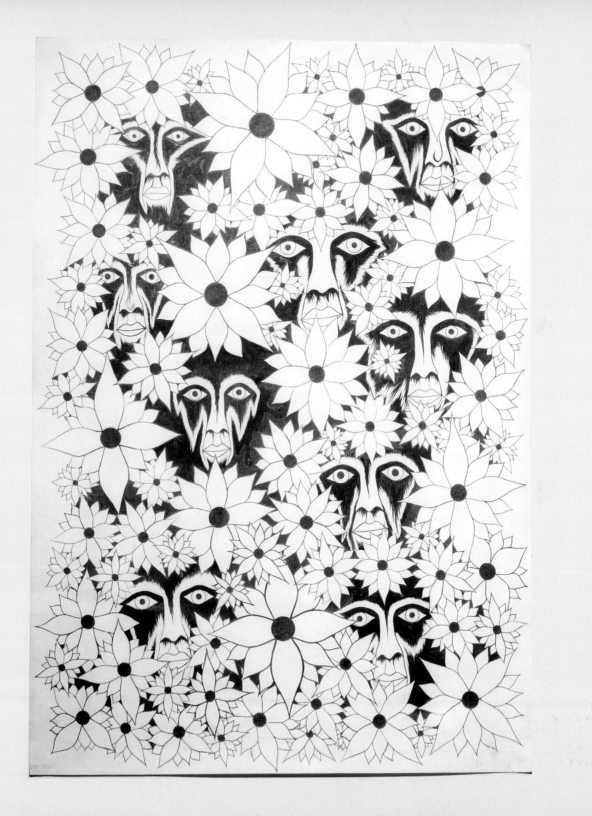

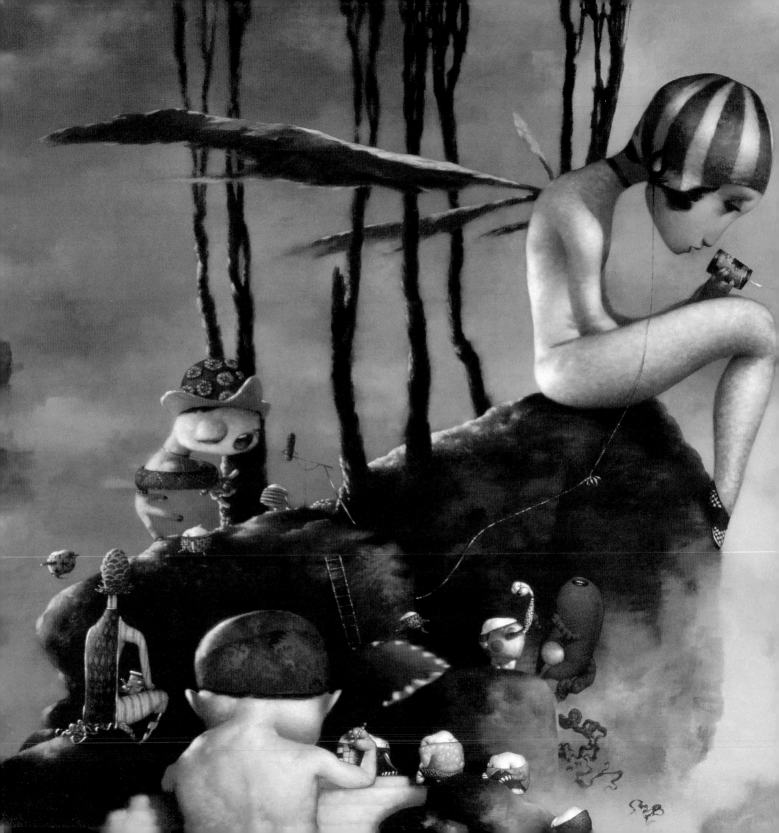

JOE SORREN

www.joesorren.com

Joe Sorren lives in Flagstaff, Arizona. You can see the influence of fine art and artists on his work, such as Turner and Rembrandt, rather than skate culture. He names his other inspirations as:

Django Reinhardt, Tom Waits, Stephen Motley, Jim Henson, Degas, Cy Twombley, Bob Dylan and this board game called Masterpiece – the seventies version.

He produces large paintings of either acrylic on canvas, or oil on panel. His artwork is in turn humorous and subdued. His muted tones and the softness of his paintings give them an ethereal quality and add to the fantasy elements in his work.

As well as his paintings he has also more recently moved into sculpture, and his first two bronzes, *Corrina* and *March of the Ballentine*, were produced in 2006.

His paintings have appeared in numerous publications, such as *The Los Angeles New Times*, *The Washington Post* and the magazines *Time*, *Juxtapoz* and *Rolling Stone*. He has exhibited across the US, in Europe and Australia.

This Spread
Arcanum for the Patron Grey, acrylic on canvas.

Following Spread
Left: **By Day I Dream of Night**, oil on panel.
Right: **Corrina**, bronze.

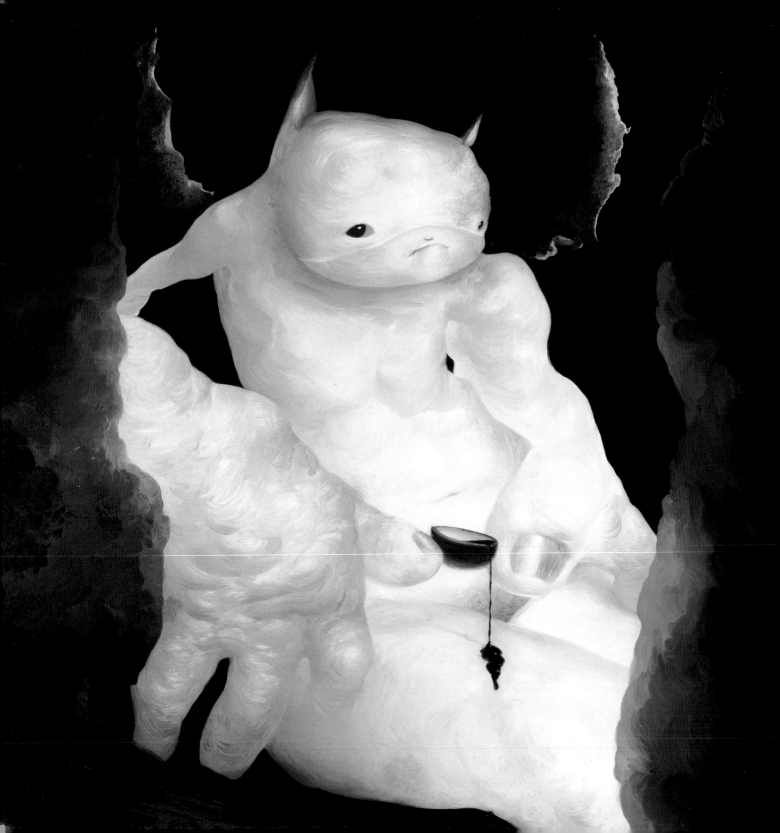

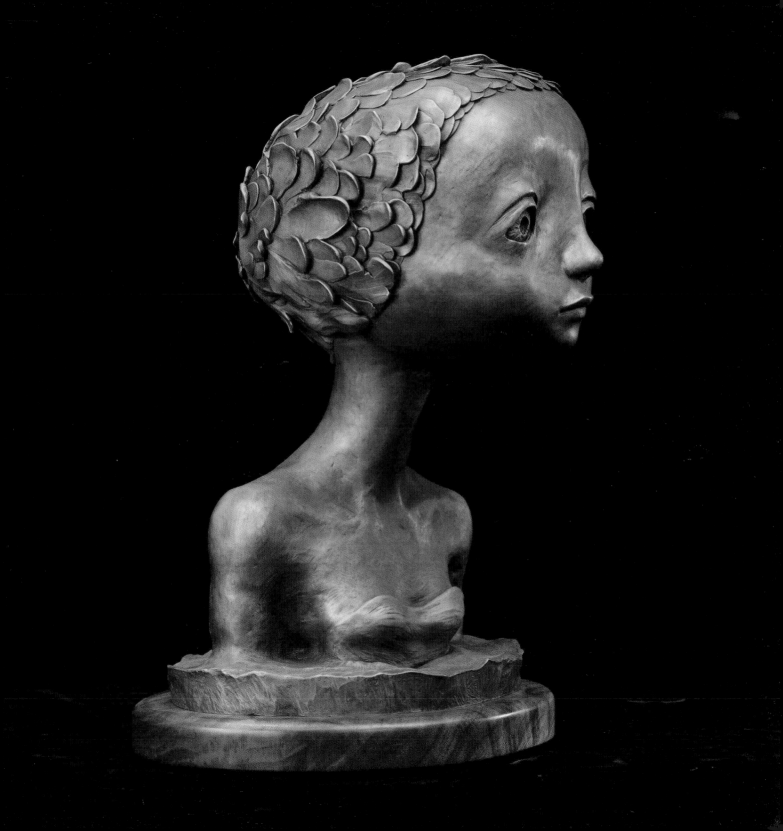

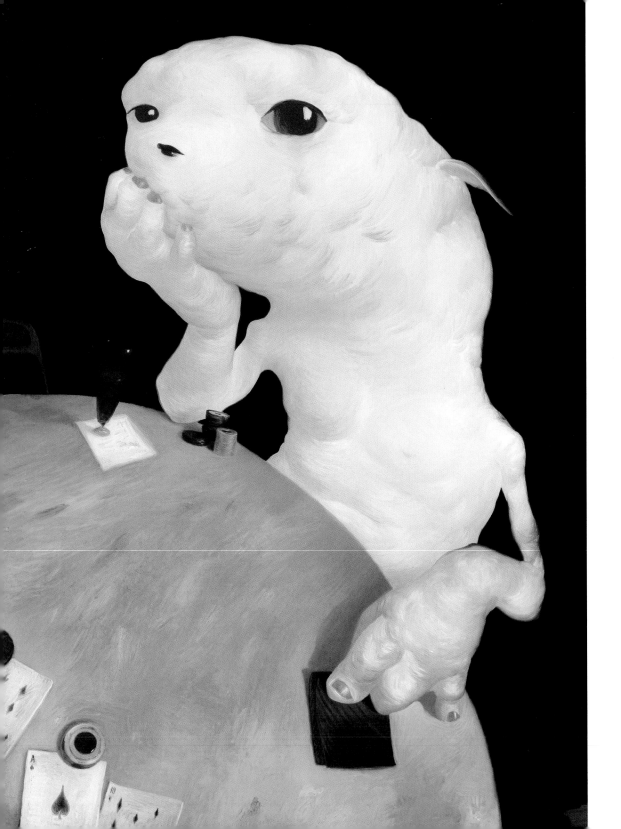

Tells, oil on panel.

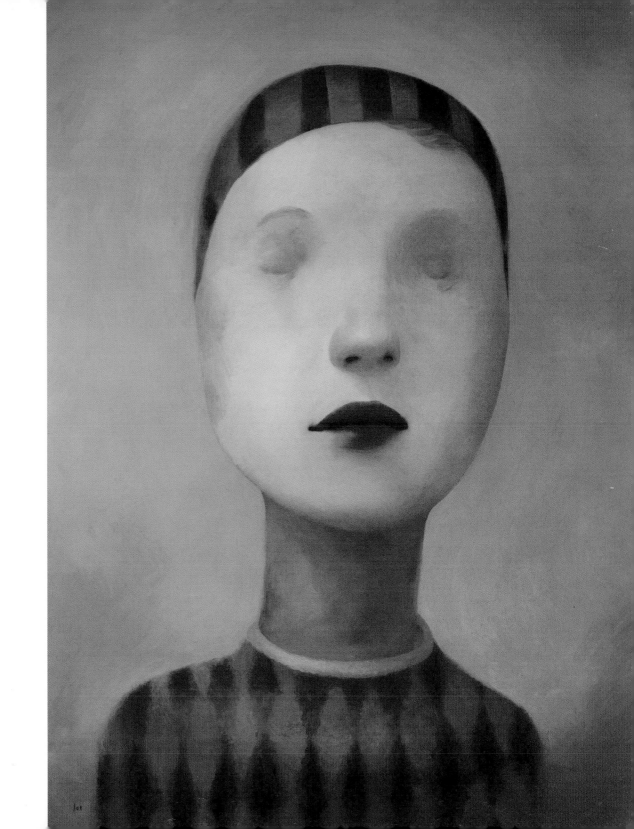

Faraway, oil on panel.

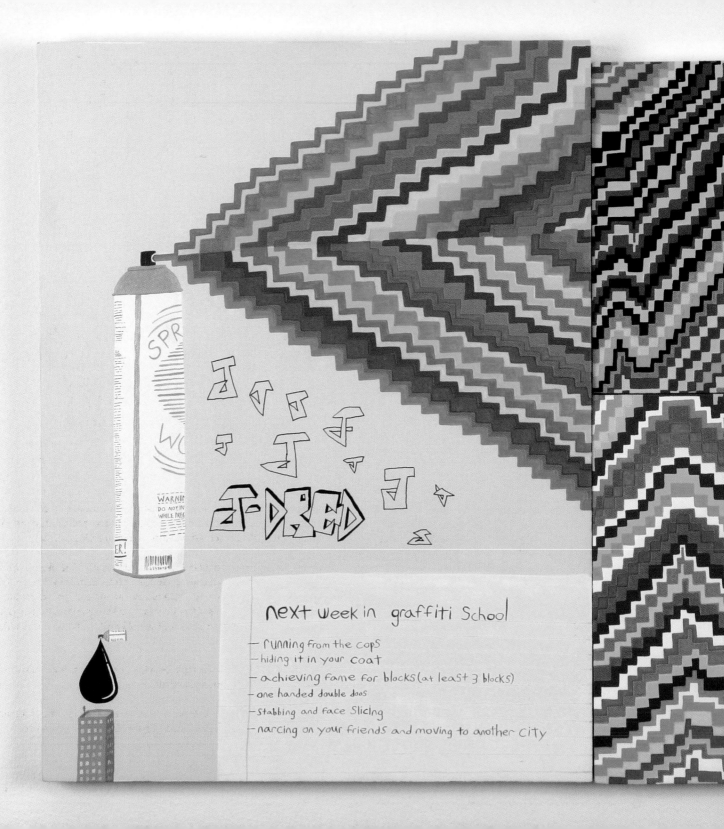

ANDREW JEFFREY WRIGHT

Andrew Jeffrey Wright's artwork encompasses drawing, screen printing, painting, video, animation, photography, collage, zines, sculpture and installation, and he describes his work as 'pretty and funny'.

He studied animation from 1989 to 1993 at art school in Philadelphia, where he is still based: he is a founding member and resident at the Space 1026 gallery and studio space. His collaborative animation, *The Manipulators*, which he made with artist Clare E. Rojas, won the top prize for animation at the New York Underground Film Festival in 2000, and at the New York Comedy Film Festival.

He has exhibited his work across the US, in Los Angeles, Philadelphia, San Francisco and New York, and in Paris.

He has been skateboarding since 1984 and names his influences and inspirations as Salvador Dali, Robert Crumb, George Grosz and dogs.

Graffiti School, oil on panel.

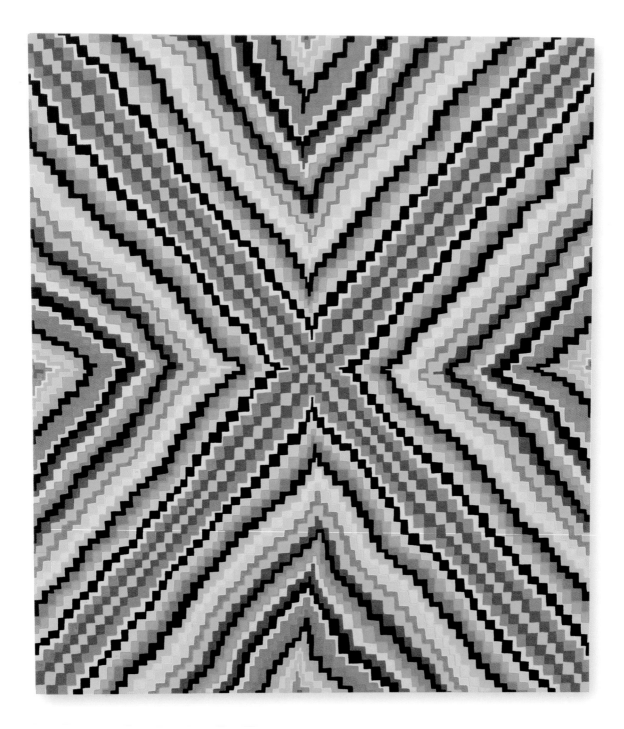

Rainbow X Wave with Black, oil on panel.

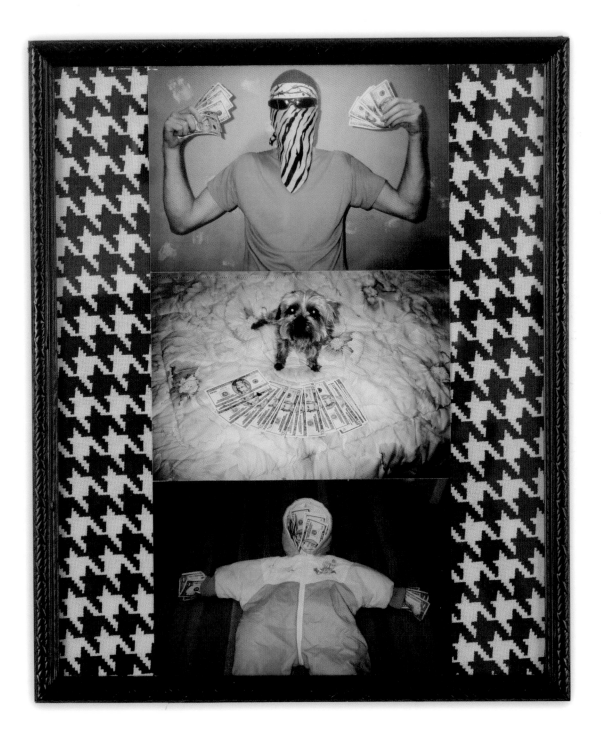

Money Shots on Houndstooth, photo collage.

I've never done any drugs. I mean for recreation. Except for when I was like nine years old I took two baby asprin when I wasn't even sick. I took them because I liked the way they tasted.

I didn't trip out or anything though. Oh and I once took half a codeine that I had left over from when I had my wisdom teeth removed, but it had no affect on me beyond a slight headache.

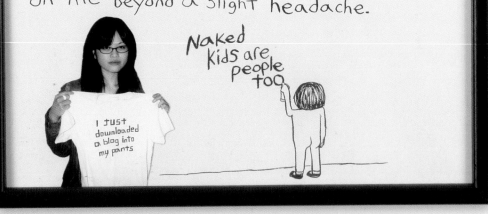

I Don't Do Drugs, ink and photo collage on paper.

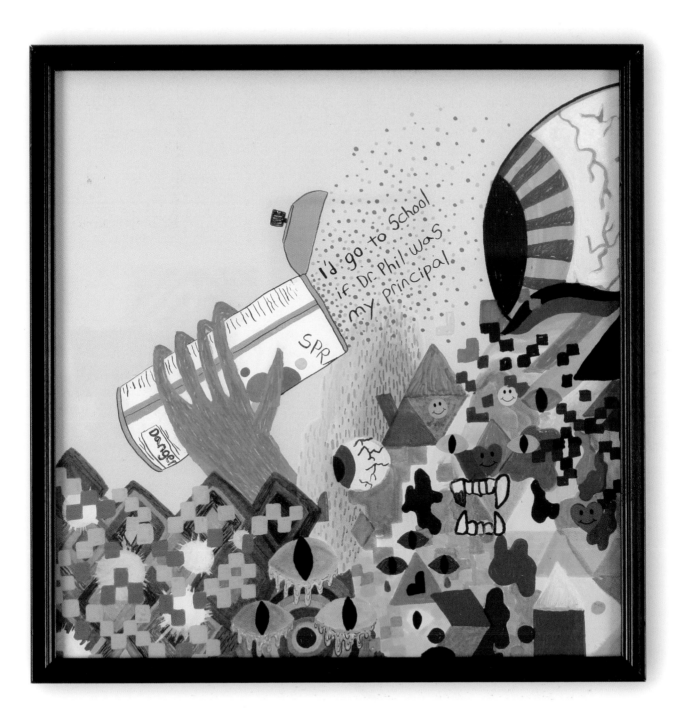

Principal Dr. Phil, oil, ink, latex and acrylic on paper. Collaboration with Jacob Ciocci.

About the Author

Jo Waterhouse was originally from Birmingham but now resides in Worcester, UK. She has been dabbling in skateboarding and art from a young age, but began combining the two in 2002 while studying art and design. Later that year she pursued those interests further by co-founding a successful online magazine as a resource for others interested in skateboarding and art.

Her first book, *Concrete to Canvas: Skateboarders' Art* was published in 2005. She is also a freelance writer, regularly contributing to *Modart* magazine, and is currently working on a creative clothing and gallery space project, 'Ours' (currently housed in Spine skate shop in Worcester), with her partner, artist Chris Bourke.

www.concretetocanvas.co.uk
www.myspace.com/concretetocanvas
www.thisisours.co.uk
www.spineskateboarding.co.uk

Thanks

My heartfelt thanks and appreciation go to Stephen Ashton, Lee Basford, Chris Bourke, Thomas Campbell, Lori D, Dave The Chimp, Chris Dyer, East Eric, Ekta, Fernando Elvira, Martin Fischer, Jeremy Fish, Flying Fortress, French, Mr Gauky, Mike Giant, Kev Grey, Stef Grindley, David Hale, Jim Houser, Jeff at MG Imaging, Thom Lessner, Majls, Finn Neary, Nomad, Simon Peplow, The Phono Art Ensemble, Yogi Proctor, product.two, Toby Shuall, Joe Sorren, Kris Waterhouse, Andrew Jeffrey Wright and all at Laurence King Publishing.

All artwork remains the copyright of the artists.